THE PRACTICE OF
TEMPERA PAINTING

BY

DANIEL V. THOMPSON, JR.

ILLUSTRATED BY

LEWIS E. YORK

DOVER PUBLICATIONS, INC.
NEW YORK

Published in Canada by General Publishing Com-
pany, Ltd., 30 Lesmill Road, Don Mills, Toronto,
Ontario.
Published in the United Kingdom by Constable
and Company, Ltd., 10 Orange Street, London
WC 2.

This Dover edition, first published in 1962, is an
unabridged republication of the work originally
published by the Yale University Press in 1936.

Standard Book Number: 486-20343-3

Library of Congress Catalog Card Number: 63-299

Manufactured in the United States of America
Dover Publications, Inc.
180 Varick Street
New York, N.Y. 10014

PREFACE

THE basis of the method that this book endeavors to explain is the account of Giottesque tempera painting given by Cennino d'Andrea Cennini in his *Libro dell'Arte;* but Cennino knew that no written instructions are enough to teach a painting method. "There are many," he writes, "who say that they have mastered the profession without having served under masters. Do not believe it; for I give you the example of this book: even if you study it by day and by night, if you do not see some practice under some master you will never amount to anything, nor will you ever be able to hold your head up in the company of masters."

Cennino was quite right. His own teaching is sound and complete, but it is not easy to understand, even when one has had some practical experience. I have studied the *Libro dell'Arte* for eighteen years, since my good friend and teacher, Louise Waterman Wise, first introduced me to it; and am far from having exhausted the instruction that it offers. I cannot suppose that my own writing will be as thorough as Cennino's, but I hope that it may be easier for the modern reader to understand and apply to modern cases. I have tried to expound the fruits of a long and valuable apprenticeship under Edward Waldo Forbes, at Harvard, and another under Edwin Cassius Taylor, at Yale; of practice under Nicholas Lochoff, in Florence, and Federigo Ioni, in Siena; and fragments of understanding which I owe to many friends in many places.

The text of this volume is based upon a dozen years of teaching and practice, seven of them in the School of the Fine Arts at Yale. I have incorporated portions of lectures and demonstrations given at Yale, at the Child–Walker School in Boston and its graduate department in Florence, at the Royal Academy and the Courtauld Institute in London, and other notes which have been used as the basis of practical instruction in these and other places. The illustrations which accompany the text are the work of Professor Lewis York, of the Yale School of the Fine Arts, whose program for intensive in-

struction in the practice of tempera painting is given in his own words as an appendix to this book. References to Cennino are given in terms of my English translation of the *Libro dell'Arte,* published under the title *The Craftsman's Handbook* by the Yale University Press in 1933; but these references have been kept down to a minimum, since the intention of this volume is to paraphrase Cennino in modern terms, rather than to comment on his text. No general bibliography is given; for I have written throughout on the basis of personal experience and judgment. The short chapter on Emulsions is, however, based on instruction received from Professor Max Doerner, with whom I had the privilege of studying *Malmaterial* at the Munich Academy in 1922–23.

I have made no effort to touch upon the significance of Cennino's writing or methods for the history of Italian art. I have left out of account all the theoretical and historical considerations which attach to it, and concentrated upon the application of his tempera medium to present-day practice in painting. This book is intended for painters, modern painters, preferably very modern painters. I shall be glad if it is acceptable to the historian as an exposition of trecento Italian techniques, but that is not its purpose. If I have looked for my material in an old, disused quarry, it is with no wish that the newly quarried stone should be used in an antique style. Parian marble could be cut in modern shapes.

I shall be glad too if this account of tempera practice makes Cennino's writing more intelligible to those who do not paint. The importance, for example, of the preliminary ink rendering on the gessoed panel has often been missed by students of the *Libro dell'Arte.* I myself failed for many years to grasp it, and might indeed never have done so but for the insight into the optical behavior of colors which I derived from the patient training of the late Professor Edwin Cassius Taylor, under whom I served in the Department of Painting at the Yale School of the Fine Arts. Professor Taylor's name must head the list of those to whom I am indebted for help and counsel.

To the Yale University Press I owe thanks for the watchful care and helpful interest with which its skilled staff never fails to surround

its authors: and for its coöperation in making available for the publication of this volume an appropriation from the Rutherford Trowbridge Memorial Fund given to the University for the benefit of its Press. The name of Trowbridge has long been bound up with the cultivation of the arts at Yale: through the Thomas Rutherford Trowbridge Memorial Lectureship Fund, established in the Yale School of the Fine Arts in 1899 by Mr. Rutherford Trowbridge in memory of his father; and, since 1920, still further through the Memorial Publication Fund established in that year by Mrs. Rutherford Trowbridge in memory of her husband. This Fund has enabled Yale University to extend the influence of the Trowbridge Memorial Lectureship by publishing important material first presented in Trowbridge Lectures at Yale. It is an honor that I appreciate warmly that this book (based largely on my work at Yale) should participate in the benefits conferred by a Foundation designed to perpetuate the memory of the magnanimous and public-spirited Rutherford Trowbridge.

To the University of London I owe the opportunity to formulate this work, and to Professor W. G. Constable, Director of the Courtauld Institute of Art, invaluable help in its preparation. A decisive factor in the publication of this study has been the liberality of the Publications Committee of the University of London in allotting to it a generous grant from the University's Publication Fund.

In addition to the active and visible collaboration of my former associate at Yale, Professor York, I have to acknowledge with profound gratitude the no less active but invisible assistance of my good neighbor and fellow painter in tempera, Mr. Henry Winslow, of London, to whose confidence and encouragement this book owes its existence.

D. V. T., Jr.

Courtauld Institute of Art,
 The University of London,
 December 1, 1935.

CONTENTS

PLATES

THE
PRACTICE OF TEMPERA PAINTING

CHAPTER I

USES AND LIMITATIONS OF THE TEMPERA

FIVE hundred years ago, Cennino d'Andrea Cennini, a painter who studied in Florence under Agnolo Gaddi, the son and disciple of Taddeo Gaddi (who was a pupil and godson of Giotto), wrote a book about his profession. Craftsmanship in painting was highly esteemed in his day; and he described in great detail all that he considered it important for a painter to know, in a work called the *Libro dell'Arte,* the "book of the profession," *The Craftsman's Handbook,* as I have translated it in the second volume of this series. Craftsmanship in painting has changed much and often in the last five hundred years, in accordance with the changing needs of painters and society. It has grown less strict in the last few generations, and that may be a good thing; but it has also grown on the whole less competent, and that is not good. Some modern painters have looked back to Cennino for instruction, and found in his *Craftsman's Handbook* some useful guidance for present-day application.

Tempera painting a strict discipline

Painting in tempera as Cennino teaches it is a strict discipline, and discipline in the practice of painting has long been out of style; but it is beginning once more to be regarded as desirable. We still set great store by individual liberty, and still resent any move which threatens to curtail it; but we have begun to recognize that our technical freedom is something of an illusion. We have begun to realize that the canvases and paints and brushes with which the manufacturers supply us dictate our technical operations in no small degree; that mechanization may be as great a tyrant as tradition; and that the modern painter is really free, in point of technique, only to this extent, that he is allowed to choose his own fetters.

Tendencies in modern painting

We have begun to strain at these invisible bonds of ours. Technical experimentation in painting is rife; and in it there seems to be discernible a logical tendency to move away from the plasticity of the oil media toward the linear character of the water media. This technical direction is a natural consequence of the subjective tendencies of modern styles. Naturalistic imitation is no longer the guiding principle of painting. We have set our faces toward the abstract, the symbolic, the subjectively conceived. We no longer require the illusionary effects of natural forms in the degree which oil painting was designed to satisfy; and need in compensation greater power of linear emphasis than oil painting naturally yields. The modernist, with an abstract conception, cares less for the illusion of bulk, in many cases, than for mobility of line.

This is no new phenomenon in the history of art. Painting has always been conceived primarily in three dimensions or primarily in two according to the degree of concreteness that the painters have sought. Line is perhaps the most direct vehicle of thought and feeling. A rendering in two dimensions tends to be general. Line can suggest a third dimension, but cannot show it. When form is modeled up in light and shade, the rendering becomes correspondingly more specific, more concrete. Symbols turn into facts, and tend to be seen with the eyes instead of with the mind. Naturalism in representation is only partially compatible with a medium which stresses line; and in the past the water media have gone out as naturalism has come in. Now that the pursuit of the external face of nature has begun to slacken off, and imitation to relax its grip, it is not surprising to find the water media—particularly tempera, gouache, fresco—showing promise of a return to favor.

The tendencies of modern architecture, too, contribute to the growing popularity of these media. The power of oil painting lies, to some degree, in its natural low key, its wide range of value, coupled with depth and richness in the darks. To preserve this power, a glossy surface is optically necessary. Oil painting with a flatted surface is robbed of its peculiar merit; but deep darks with glossy varnish on them do not agree so well with the many windows and light

walls of modern interiors as with the more rich, ornate, or somber settings provided by architecture in the past. The water media, with their natural high key and matte surface, together with a certain crispness natural to them and foreign to oil paint, fit the decorative requirements of modern architecture better than the oils and varnishes of past generations. If a painting in tempera is varnished, the surface may be flatted without injury to the effect.

The media of the future

I do not think it likely that modern painting and the painting of the future will find solutions of its technical problems in a return to the fresco and tempera methods of Renaissance Italy. It is probable, indeed it is certain, that we shall evolve methods of our own to meet our special needs. I do think, however, that the next reigning technique will have some fundamental elements in common with these ancient water media, and that adjustment will gradually be made in the direction of a discipline as economical and flexible as Cennino's. I believe, moreover, that acquaintance with a technique from the past which points to solutions of some problems which exist today will advance the pursuit of the ideal methods for our time.

Painters who have submitted themselves with "enthusiasm, reverence, obedience, and constancy" to Cennino's teaching have found themselves strengthened in the practice of other methods than his. They have continued to paint in tempera or returned to painting in oil with no feeling that their submission had cost them any personal liberty, and with some gain in clarity and power. There is freedom within limitations; and modern painters may find in the practice of tempera according to the strict plan of Cennino's work a path of escape from a tyranny of modern technical convention which is no less stringent because its bondage rests upon them so lightly.

The limitations of tempera painting

Tempera (in the sense in which the word is used here) is an instrument of precision which accomplishes a certain set of purposes perfectly, and which for some other purposes is useless. Whether it

is a useful system to a modern painter depends on what the painter wants to do. If he wants to sketch, and feel his way, and capitalize happy accidents, it will be no good to him. If he wants to catch the essence of some passing moment in his painting, some instantaneous effect of atmosphere or expression, to suggest some elusive, indescribable effect, Cennino's mantle will hang heavy on his shoulders. If he has a well-defined pictorial idea, he may do well with it. Tempera is good for rendering certain types of clearly formulated graphic conceptions. It requires clarity in formulation. It cannot adapt itself to any vagueness.

Normal scale

Tempera has other limitations. It is not well adapted to works of large size. A tempera panel may be pushed say to six or eight feet in its largest dimension; but that puts some strain upon the natural scale of the method. The normal range that it covers comfortably and easily and naturally lies between twenty square inches and twenty square feet.

It is not well adapted for painting in a low key. The natural pitch of tempera is medium to high. Patterns of dark in dark tend to appear muddy or obscure in tempera. It operates naturally in a higher register than oil; and though it possesses the power of going down to dark, it is most successful when not forced out of its natural range. What is high for the 'cello is low for the violin, and the violin shows its special character in a region which the 'cello can hardly achieve. So in tempera it is possible to work among a range of high values which in oil can be achieved only at the expense of vigor and permanence.

Finally, tempera is not adapted to the production of a warm tonality. It tends to work cool. It has to be forced if it is to yield at all the warmth and richness that oil painting yields naturally. It possesses no such extremes of warm and cool, or transparent and opaque, as oil, and no such power of rendering deep, saturated, warm colors. Reds, oranges, and yellows tend to seem cool in tempera when compared with oil; and if they are overstressed they seem to turn hot without ever becoming warm. In compensation, the cool

colors possess incomparable clarity and freshness in tempera, and retain these characteristics indefinitely.

If a painter wants to paint large pictures, or dark pictures, or pictures with a rich, warm glow, he definitely does not want to paint in tempera. If he wants to paint pictures less than forty, or better, less than twenty, square feet in superficial area, in a fairly light, fresh, blond tonality, this method may apply. If he accepts the fundamental physical limitations, the moderate size, the high key, the cool tonality, he may then consider the stylistic limitations. He may judge whether his subject can be reduced to a precise pattern of clearly defined shapes and tones. Tempera permits any degree of complication or elaboration; but it must be deliberate and definite. Paradoxically, its power of rendering abstract conceptions depends largely upon this rigor of its technical requirements.

In practice, it is difficult to effect small incidental variations of color, such as are commonly practiced in oil painting, and also perfectly smooth transitions from one color to another. The tendency of the medium is to impose the use of methodical color changes in each area of the design separately. The painter is also subject to some limitations in passing from one value to another. In the plastic medium of oil paint it is possible to blend adjacent values so perfectly together that they merge in a continuous value progression. In tempera this can hardly be accomplished. The bones of the modeling, the transition from one value to the next tend to be more evident; and these evidences of articulation, though valuable to the painter of ideas, are troublesome to the painter of appearances.

Factors in naturalistic painting

Nothing goes further to determine the degree of concreteness that a painting shall display than the treatment of light and shade. If a naturalistic system of lights, half tones, shadow edges, reflected lights, and cast shadows is used, the objects represented will necessarily appear specific. They are bound to tell in some degree as certain solids seen under certain conditions. This is true though the objects and conditions may be as far divorced from any normal natural phenomena as the most extreme stage phantasy. This solidity and

this precision of the atmospheric setting may be either a power or a limitation to the painter. They are a power when the ideas of bulk and reality are part of his subject matter. They are a limitation when he wishes to be understood in general, subjective terms. It is often an advantage to a portrait painter to be able to create the illusion of reality upon his canvas. It is often a disadvantage to a painter of the Crucifixion to have his work look like a *tableau vivant*. It is fatal when his aim is to express some general aspect of the spiritual significance of his subject.

Tempera lends itself readily to any system of light and shade, abstract or scientific. But its limited value range, overbalanced toward light, makes it less persuasive in a realistic scheme than oil painting. It is for this reason possible to use a scientific arrangement of lights and darks to render form without obtaining an obviously realistic result; and this paradox is not without its usefulness. Any system of light and shade may be employed in tempera, from the elementary, ideographic, medieval types, to the most highly descriptive analysis of form.

A great factor in naturalistic painting, in which oil painting outstrips tempera, is the recognition of modifications of local color according to the degree of illumination. In nature, a change of value is always accompanied by some change of color and intensity. A change in value in painting is also accompanied by some change of color and intensity, but not necessarily the same change which takes place in nature. Naturalistic painting requires that each color appear at its maximum intensity in the full light, and that its intensity diminish with reduction of the illumination. At the same time, the color itself is progressively modified. These modifications are extremely complex. They depend upon the character of the light, the setting of the object, its relation to other objects, its color, its surface, and its material composition. To represent these changes fully and accurately is to pursue the specific quality of the subject to the end. This may be attempted in oil painting without much added difficulty; but it would mean vast trouble for the tempera painter to try to bring his color changes into even rough agreement with those that he observes in nature. The tempera painter accepts as a condi-

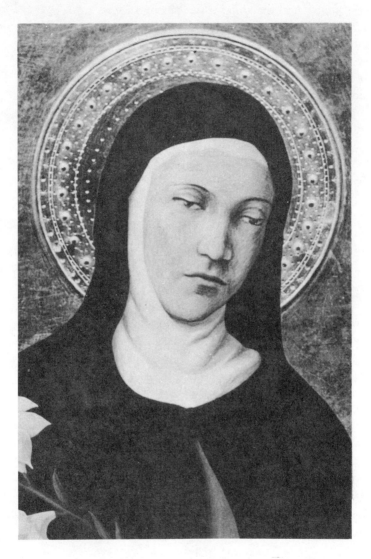

DETAIL FROM ST. CLARE BY CLARE FERRITER.

tion of his work the conventional substitution of some system of pigment color changes in lieu of the color changes produced by light in nature. This substitution may occasionally approximate natural phenomena; but it is generally arbitrary and abstract.

A critical approach

Tempera requires either the rejection of the naturalistic ideal or a critical approach to naturalism, a willingness at least to reduce the complexity of nature to one of many possible systems of convention for the sake of subjective emphasis. It is in every way unsuitable for the use of a painter whose aim is the reproduction of the superficial appearance of natural objects.

I have set forth the limitations of tempera at some length; for it seems to me essential that they should be understood. Its weaknesses for one purpose become strengths for another. Devotees of this medium (and it inspires warm devotion in those whose needs it fits) tend sometimes to exaggerate its powers and qualities. I am anxious to have its worth appreciated, and its application to modern uses extended as far as this extension is justified; but I am keenly aware that there are many problems in modern painting which it will not solve, or perhaps even help to solve. Tempera is no panacea, but a medium of limited applicability which within its limitations does a perfect job.

CHAPTER II

CARRIERS AND GROUNDS

THE first problem that a modern tempera painter has to face is the choice of a material for his panel, a carrier for the gesso ground upon which the gilding and painting are performed. This was not a serious problem to Cennino, in medieval Italy. He simply used a wooden panel, "whitewood or poplar, linden, or willow." Some conscientious carpenter friend of his supplied him, we may suppose, with what he needed. The stock from which the panel was cut was probably old, loft-dried wood, properly conditioned as a plain matter of course. "See that the wood is thoroughly dry," is all Cennino's warning. But dryness means many things, applied to wood nowadays; and the modern painter must be cautious. Wood for painting purposes must be cured slowly, not kiln-dried. Kiln-drying simply cooks the water out of green wood, and leaves it too dry, too readily affected by moisture, and liable to warp and crack. Even old, air-dried wood will warp if it is much cut or planed.

Properties of wood

Wood has certain properties which make it a desirable carrier for painting. It is easily cut and worked to shape for flats, moldings, and carvings; it is strong, not easily bent or broken; and its fibrous structure is readily penetrated by a hot size solution, so as to form an excellent bond between wood and gesso. The disadvantage of wood lies in the unsymmetrical arrangement of its fibers, its grain.

Under the influence of moisture, wood expands, chiefly across the grain; and under the contrary influence of dryness, it contracts in an opposite degree. Humidity fluctuates in most environments, and a wooden panel is therefore constantly subject to expansion and contraction. When these changes are gradual, the wood keeps step with them, and does not suffer; but when they are sudden, a panel will

often warp, or split, or change so rapidly as to loosen the bond with the ground upon it. Conditions of moisture at the front and back of a panel may easily be very different, with the result that while one face is being expanded, the other is standing still, or even being contracted. Thus, a panel on a cold wall may be damp at the back from condensed moisture, even though the front be exposed to air dried out by heat or frost. These conditions may to some extent be controlled; and to that extent wood may be used successfully for paintings.

WHITEWOOD
MAGNIFIED
60 DIAMETERS

Effects of humidity

The medieval painter did not have to consider the effects of central heating. In medieval buildings, unheated, atmospheric changes were gradual. The temperature shifted somewhat with the seasons, but the changes were slow, and the humidity of the air was not subject to such violent modifications. In the open atmosphere of an unheated stone building, wood is an admirable base for painting. In a modern house, often hot by day and cold by night, with corresponding sudden changes in relative humidity, parched in winter, and often swollen with damp in summer, wood may crack and warp disastrously, no matter how well it has been seasoned. If air-conditioning in modern buildings becomes a general practice, it may be possible once more to use wood generally for painting; but at present it is risky for any but small works, unless a stable environment can be foreseen.

Selection and conditioning of woods

If wood is to be used, a soft wood should be chosen, as Cennino advises. Birch, maple, and oak may be used, but they are heavier, harder to work, more costly, and seem actually to give a somewhat less good bond with the gesso than the soft woods. Bass, whitewood, poplar, and the bay which is sold as mahogany are satisfactory, as

long as they have been properly conditioned. Pine, spruce, and fir must not be used; for they contain soft resins which tend to stain the ground and the painting. Whatever wood is chosen should be cut into planks somewhat thicker than the panels to be made from them. It should then be spread out on rafters to dry, and shifted and turned about at intervals for at least a year. This seasoning should take place in a normal atmosphere, the sort of atmosphere in which the panel may be expected to stand after it is done. At the end of a year or two, the seasoned planks may be made up into panels. They will probably have warped a little, and some planing will be necessary to make the panels flat. After this, the wood will probably warp again, so the panels should be placed on the rafters, fully exposed to the air on all sides, for several weeks, and then allowed to stand about the studio for several weeks more, so that their behavior may be watched. If there is any warping, they may be planed down again, and the seasoning continued. It is folly to attempt to paint on a panel which has not demonstrated its stability over a substantial period of time.

One might suppose that by securing old wood, using old table-tops, paneling, floor boards, which had seasoned for years, this process might be shortened. So it may; and this is excellent practice. But the use of old wood does not eliminate the need of further seasoning if the surface is interfered with by sawing or planing. No matter what the wood may be, once the panel is made up it should be watched for some months before anything is painted on it, and even before it is gessoed. I have seen a twenty-four-inch panel cut out of an eighty-year-old walnut table-top warp in an arc two inches high, though the wood had stayed perfectly flat in the table-top for eighty years before.

Casein glue for joining

If it is necessary to glue up a panel, the best thing to use is the cheese and lime glue which Cennino describes in Chapter CXII.[1] I have seen a medieval panel, made up with this cement, which was

[1] *The Craftsman's Handbook,* p. 68.

so completely eaten away by worms that the cement which origi-
nally joined two parts together stood out in a thin ridge half an inch
high, with the marks of the grain of the wood visible on both sides
of it. It is durable, adhesive, and, once dry, insoluble in water.
This insolubility is a great advantage; for the surface of a panel is
kept moist for a long time in the process of gessoing, and ordinary
glues tend to soften dangerously if they are kept damp. If the panel
is so wide that it cannot be cut from a single plank, two or more
planks may be put together with this glue, with broad clamps to
hold them while it dries, of course. Moldings may be glued to the
panel with it, and nailed through in addition with copper nails, or
brads. There are several proprietary casein glues on the market now
which are good and useful, but for gluing wooden panels Cennino's
lime-casein recipe is better. The alkaline principles of the trade ca-
sein glues are more soluble than lime, and may do damage; and the
dried film which these products leave behind resembles a glue, while
the lime mixture resembles a cement, and is better suited to use in a
joint between two pieces of wood. Cennino's recipe is easily fol-
lowed, using any lean cheese, "mouse cheese," or even "cottage"
cheese, consisting of fresh curds strained from the whey. Be sure to
get pure lime, and not the compound material called "Hydraulic
lime" which many builders use instead.

Precautions against warping

Several methods are used to control the movement of wooden
panels. The most satisfactory, when well performed, is cradling. To
form a cradle, high, narrow strips of wood are glued to the back of
the panel in the direction of the grain. In these strips, notches are
cut, to fit next to the panel, and into these notches transverse strips
of wood are fitted but not glued. These transverse strips act as a firm
but gentle spring, resisting the tendency of the panel to warp. Good
cradling is rare. Most workmen err in making the grain-wise strips
too wide. The design and arrangement of the fixed strips, the loca-
tion of the transverse strips and their adjustment in the notches, call
for expert workmanship and judgment which not every carpenter
possesses.

People who do not know the character of wood often suppose that it can be kept in shape by strong measures. A student of mine once

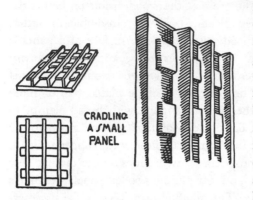

CRADLING
A SMALL
PANEL

fastened bars of iron securely to the back of a narrow panel, across the grain, believing that they would make it impossible for the wood to warp. The wood did not warp: it couldn't—so it cracked instead! Warping may be discouraged by the gentle action of a good cradle; but this expedient is applicable only in the case of well-seasoned wood. No cradle can be expected to oppose the violence of wood in which the sap has not been properly dried and set. The seasoning of wood brings it into equilibrium with the atmosphere, and well-seasoned wood will accommodate itself to gradual atmospheric changes of limited extent without difficulty and without special precautions. If the changes are rapid or extreme, as they often are under modern conditions, a good cradle is needed to keep the panel in shape while they act upon it.

Plywoods

Another method of treating wood for use in panels is by lamination. If a panel is built up in layers, with the grain of the wood in one layer opposing that in the next, it is possible to make a beautifully stable thing of it. Unfortunately, far more bad panels of this sort are made than good. The arrangement of the grain is often ill considered; inferior and badly seasoned woods are often employed; and the adhesion among the component parts is often far from perfect. I once purchased a plywood panel from a firm of colormakers of international reputation and had the disconcerting experience of seeing it come apart, layer by layer, in the course of little over a year. I have been well pleased with a plywood made for airplane manufacture out of very thin sheets of rotary-cut veneer, birch and

mahogany, cemented together with a blood-albumen adhesive chemically not unlike Cennino's cheese and lime glue. This kind of plywood is prepared for oil painting with a special gesso by an American artists' colorman. None is offered for sale, as far as I know, ready prepared with a proper gesso for tempera. Cheap, non-descript plywoods must be avoided at all costs; for they are sure to blister or peel. A good cabinetmaker can put together splendid laminated panels to order, if he can be persuaded to interest himself in the painter's problem. He will usually prefer to use hot hide glue to fasten the layers together, and this is good practice. If he is open to suggestion, he may be furnished with a supply of cheese-lime glue, and this is even better. If he shows signs of wanting to glue the layers with cold liquid glue, he is not a good cabinetmaker, and should be shunned; for he cannot be cured.

Wood pulp boards

The natural structure of wood can be broken down mechanically or chemically, and the fiber converted into artificial boards. There are many boards of this sort on the market, for building purposes; but few of them are good for painting. If wood is ground up, it has to be put together again with an adhesive such as glue, and the re-sulting product is both too weak and too hygroscopic for a large panel of reasonable thickness. Poor wood and low-grade glue are usually employed in these ground wood pulp boards. Still worse are the boards made from wood reduced to pulp by the action of chemicals. Sulphites and chlorides remaining in the pulp are injurious to the painting and to the fibers of the panel itself, and boards of this sort often disintegrate within a few years, turning yellow and brittle like old newspaper—to which they are, after all, equivalent. Good pulp boards are made, without the addition of any foreign adhesive, out of wood alone, by subjecting the pulp to the action of super-heated steam and hydraulic pressure. The substance of the wood it-self is made sufficiently cohesive by the moisture and heat to be welded together by the action of the press.

I am reluctant to recommend any commercial article by name, partly because of a strong prejudice against seeming to advertise a

trade product, and partly because conditions of manufacture are not necessarily permanent, and what one has found good in the past may not be found good in the future. In view of the difficulty of finding satisfactory materials for panels at short notice, however, I will say that my students and I have for seven or eight years used a commercial building board made under the name of "Masonite," both a thin sort called "Prestwood" and a thicker, called "Quarterboard." I cannot take the responsibility of recommending these products; but I know of no objection to them as they are now produced, and my experience of several hundred panels made from them has been entirely satisfactory. For large works, two or three thicknesses can be glued together. This material can be steamed and bent or pressed into any required shape.

Paper

Closely related to the wood pulp board is linen paper, made from linen rags beaten and shredded into pulp, and a small amount of size to act as a binder. Paper is, of course, flexible; and rigidity is essential in a carrier for the nonflexible gesso. Good linen paper would be an admirable carrier for paintings of moderate size if it were solidly mounted and protected from the mechanical danger of puncture. This can be done by stretching the paper on a wooden

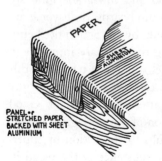

PANEL of
STRETCHED PAPER
BACKED WITH SHEET
ALUMINIUM

frame, with a sheet of aluminium between the paper and the stretcher. The edges of the metal should be rounded off; and it should fit the stretcher exactly, but should not be fastened to it. The paper may be damped, stretched, and pasted or glued in the usual way, and tacked to the frame for good measure. Panels of this sort may be made easily up to 20″ x 24″. Without the metal backing, the stretched paper would not be firm enough to stand the pressure of scraping or burnishing, and would be easily pierced by a blow from front or back. An alternative method is to stretch the paper over a sheet of aluminium which in turn lies on

a sheet of plywood or building board, gluing the turnover of the paper to the back surface of the board. A steel-faced plywood is made for airplane manufacture, and may be used for this purpose, though it is rather heavy. Paper is best backed with metal, and should not be fastened to it, but only stretched over it. In all cases, a thick, pure linen, handmade paper should be employed.

PANEL of PAPER
STRETCHED AROUND
A METAL-FACED
BOARD—

Metals

There have been many efforts to use metals themselves as carriers for gesso grounds; but they have not generally been rewarded with success. The chief difficulty is, of course, to make the gesso adhere properly to the metal surface. But even when this can be accomplished, the result is not altogether satisfactory. Except for aluminium and magnesium, and alloys of those, metals in panels of sufficient thickness to be rigid are usually objectionably heavy. And if it should ever be necessary, for any reason, to remove the painting and ground from the original carrier, as must sometimes be done with old paintings, a metal panel makes heavy labor for the restorer. A successful method was patented some years ago for making panels with oil-gesso on an artificially roughened aluminium surface. In general, however, the lack of porosity in metals makes the bond with the ground uncertain; and I know of no reliable method of overcoming this difficulty which would commend itself to a practicing craftsman.

Canvas

Gesso grounds for painting need not necessarily be rigid. It is possible to paint in tempera on canvas, as Cennino directs.[2] The best

[2] *The Craftsman's Handbook*, p. 103.

material for this purpose is a fairly closely woven linen crash or twill, preferably the latter, as it has a firmer structure. This should be washed thoroughly, to remove the manufacturer's sizing, and to make it change as much as it will. Two washings with hot soapy water, and thorough rinsing and drying after each, should be a minimum of preparation. Tack the linen to a canvas stretcher, taking great care to get it evenly taut all over, and to have the tacks properly lined up with the weave. Size it with one-to-sixteen gelatine solution, made as described later in this chapter; and when the size is dry, put on one coat of gesso sottile[3] made up with some of the same one-to-sixteen size, adding a teaspoonful of white granulated sugar to each eight ounces of the size. The sugar makes the ground a little hygroscopic, and hence flexible, but should not be used in excess. The gesso is applied to the stretched, sized canvas with the blade of

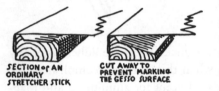

SECTION of AN ORDINARY STRETCHER STICK

CUT AWAY TO PREVENT MARKING THE GESSO SURFACE

a spatula, and worked into the grain. Then as much as possible is scraped off again with the blade. If an ordinary oil canvas stretcher is used, the canvas will be badly marked unless the upper faces of the stretcher sticks are cut away more steeply than usual. Actually, special steeply beveled stretcher sticks should be made to order for this purpose.

The stretching of a canvas which is to be prepared on the stretcher requires a little extra care. The raw, unsized linen is hard to stretch evenly. The work must, however, be done accurately, beginning with the center thread on each side, and tacking at equal intervals toward the corners. The strain must be distributed evenly, and it is usually necessary to draw the tacks and replace them several times before a perfect result is secured. No slack should be left to be taken up later by driving in the corner pegs. It is wise to start with the pegs driven half-way in, so that the strain can be relaxed and restored slightly as the canvas shrinks and stretches during the sizing and gessoing. When finished, a canvas of this sort is better left per-

[3] See p. 37, below.

manently on the stretcher and not rolled; but it can be rolled fairly safely, if necessary for transport, if it is turned around a tube of large diameter and the face of the painting kept on the outside. A flexible canvas prepared by a patented method of controlled tension is available commercially in England.

Walls

Finally, we may consider the possibilities of painting in tempera directly on plaster walls, or applying gesso grounds to existing plaster surfaces. Either of these procedures is possible; but neither is advisable for serious work under ordinary modern conditions. For large or informal decorative purposes, it is often desirable to paint directly on an existing wall; but for these purposes a broader-working tempera will be wanted than that described in this book.[4] Extensions of tempera technique to large-scale decorative painting cannot be treated in detail in this introductory discussion; but they are easily mastered by anyone who has learned the basic principles of tempera handling. It is possible to paint on a wall in pure egg tempera; but modern builders' plaster usually contains injurious salts, and the result cannot be guaranteed. The wall may sometimes be sized and papered. Gesso may be applied to a papered wall; but it is a laborious process, if much space has to be covered. It is not safe to apply gesso to fresh plaster directly, or indeed to any plaster of the kinds now almost universally used. An old wall, plastered with pure lime and sand, may be painted in tempera, and gessoed wherever perfect smoothness is required; but gypsum plasters, plasters containing alum and magnesia, and plasters laid over rough coats which contain Portland cement, are unsuitable grounds for any kind of painting, whether in tempera or oil. Tempera painting of the type under discussion here is particularly applicable, however, in connection with paneled walls, or architectural woodwork in general.

Preparation of panels

There are several good ways of preparing a panel to be gilded or

[4] See Chapter VIII, below.

painted, and a thorough craftsman may want to understand them all. A beginner, however, simply wants to know one good working system which will not require experience that he has not had. The rules for gessoing which follow here will produce good results in the hands of any careful workman if they are followed exactly. They have been tested by many people over many years, and found reliable. The type of gesso that they produce is entirely satisfactory for all ordinary purposes; and if you learn to handle it easily and familiarly, you will acquire the judgment and experience necessary for success with the more perfect but more complicated process described by Cennino, discussed at the end of this chapter. Even after you have learned to work in Cennino's way, you will still find plenty of use for this simple method.

Materials

You will need some gelatine (either leaf or granulated), some whiting, a double boiler, balances, a measuring glass, a stove of some sort, or a supply of very hot water, a bowl or two, some cheesecloth, and a proper brush. The best brushes for the purpose are what house painters call "sash tools."

The standard size solution

Weigh out an ounce of gelatine, and put it to soak in sixteen ounces of cold water in the top part of the double boiler; and when it has softened up and swelled thoroughly (which should not take more than ten or fifteeen minutes), put some boiling water into the bottom part of the double boiler, replace the top part, and set it on the stove. It is not necessary for the water to reach the bottom of the top part of the boiler, and if it does, it is apt to boil over. All you want is a cloud of steam rising from the water and heating the upper container and its contents. Never heat this size solution except over hot water. It is very easy to burn it or discolor it if you use direct heat, and it will be perfectly safe over the water bath. Stir the gelatine until it is dissolved, and make sure that no undissolved bits stick to the bottom or sides of the container. If you are doing a small job, you will not need all the solution at once, and you may

pour half of it off into a bowl, to be used later on. Cover it, and keep it in a cool place.

Sizing the panel

The panel may be sized with this hot solution alone; but it is a good plan to add a little whiting to the liquid at this point, in order

to provide a better tooth for the coats of gesso which are to follow. A tablespoonful of whiting, more or less, in the eight ounces of hot size is enough. Put it in and mix it up thoroughly with a sash tool. Keeping the mixture as hot as the boiling water underneath it will make it, apply it quickly and evenly to the surface of your panel. A small panel may be brushed over with the hot size from end to end, and then "straked" off from side to side with the brush almost dry. On a large panel, the size will cool and set before you can get it covered; and it is a good plan to make a practice of painting out sizes and gessos in squares about five or six inches each way, brushing

the mixture on vigorously in one direction, and immediately straking it off in the other direction, running the brush lightly and crisply across the marks left by the first application. This will go far to obliterate brush strokes and uneven covering, and you will find that you can get the size mixtures on smoothly before the gelatine which they contain has a chance to set. Once gelatine has set on the panel, it cannot be stirred up again with the brush without making the work untidy. Your brush should hold plenty of size, and should be dipped often into the hot mixture. If the size gets cool as it is put on, it stays on the surface of the panel, and does not penetrate as it will if it is hot and liquid.

When the whole surface of the panel has been thoroughly covered in this way, let it dry at least overnight. Do not attempt to hasten the drying of this or any of the other materials used in gessoing or tempera painting. Gradual, even drying is essential to successful work. The workroom should not be overheated, as in a hot, dry atmosphere the surface of a size coat may dry and harden while the under part is still quite wet. But the room should not be too cold either; for size mixtures are awkward to handle if the air is chilly enough to make them set quickly. They are slow to dry in a cold, damp room. Take particular care not to place panels which are being gessoed in any spot where direct sunlight may fall on them while they are drying; for the heat of the sun on the damp gesso is

sometimes enough to cause bad cracks. They should be set out of a draught, also. Overnight in a room which has been comfortably warm during the day is a safe and convenient rule; for size is always best dried in a falling temperature. If you can give this coat two or three days to dry, it will be still better.

Applying moldings and ornaments

If there are any moldings to be applied to the panel, they should be sized in the same way with the hot gelatine and whiting mixture. This sizing should be applied

to the whole surface of the moldings, tops, sides, and bottom. To do this, it is convenient to size them in one position, and when the size is dry to the touch, turn them over, and size the other side.

They may then be supported on pins or other light supports until they and the panel are entirely dry. To fasten them in place, they should be set in position on the panel, fitted and joined where necessary, and their outlines then marked on the panel with pencil. Soak a piece of carpenters' or cabinetmakers' hide glue overnight, and take it out of the water and melt it by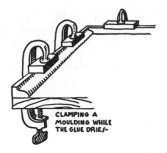

CLAMPING A MOULDING WHILE THE GLUE DRIES.

itself. If necessary, add a little hot water to it; but it should be very strong. Put a thin coat of this on the bottom of the molding, and a thin coat also on the panel where the molding is to come. Immediately set the first piece of molding in place, sliding it up to the pencil line, so as to avoid air bubbles; and promptly apply enough clamps to hold it in close contact, using blocks between the jaws of the clamps in order to distribute the pressure. With a slip of hardwood, remove any excess of glue which may be forced out at the edges, so as to leave the joints clean and crisp. Wooden moldings

should be further secured by the use of copper brads. Countersink the heads of the brads, but not too deeply.

Carved wooden ornaments may be fastened to the panel in the same way as the moldings around the sides. Any degree of relief may be secured in this way. Small castings are sometimes useful too. They may be made with plaster of Paris mixed with a solution of glue instead of with water; an ounce of glue in a pint of water gives an extremely hard, tough casting. These castings are glued in place with strong glue, and the gesso applied over them, so that they look as if they were integral with the panel, carved out of the same material. Composition materials of many kinds can be used for combinations of sculptured elements with the painting: papier mâché, mixtures of sawdust and glue; but we are concerned with the simplest usual operations here, and must not go too far afield. Moldings applied to the panel and gessoed along with it, gilded or colored in place, form for many purposes the most satisfactory sort of frame. Very simple elements will sometimes do all that is required.

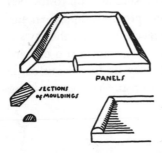

The longer you leave the clamps on the moldings, the better. Twenty-four hours is a minimum for good practice. When the clamps are taken off, you will often find that there is a little work to be done with the gouge or chisel, to improve the joints and angles. All loose fibers should be cut away sharp, and any projections caused by careless cutting, or fragments of glue or foreign matter accidentally caught on the surface, should be removed at this stage, or they may show up in the gesso surface later on.

The second sizing

When you are ready to go on, make up a solution of gelatine as you did before, and add a little more whiting to it this time—say two tablespoonfuls in eight ounces of the size. If you have kept the spare half of your first lot in a cool place and covered, you will find

that it is still good even after several days. If it is moldy or liquid
or bad smelling, you must throw it away and make up a fresh solu-
tion; but otherwise you may use what you have kept over. Apply a
second size coat exactly as you
applied the first, but this time
you will size the moldings and
ornaments along with the flat
of the panel. Work the size
thoroughly into all the corners
and hollows of the moldings

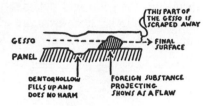

and ornaments, and particularly into the little holes produced by
countersinking the heads of the brads with which they are fastened
on. Take pains to avoid leaving drops or runs of the sizing mixture.
The best way to avoid these, when working over an irregular sur-
face, is to use a sort of jabbing or poking motion, with the brush
only moderately full of size, and then to clean up with brisk sweep-
ing strokes afterward. When you paint out squares of the size mix-
ture on the flat, do not have the edges of the squares in one coat
coincide with those in the previous coat.

This second size coat must be allowed to dry like the first, at least
overnight. Do not try to hasten these drying processes. When you
are perfectly familiar with the behavior of the materials, you may
want to risk taking short cuts in an emergency; but they are always
dangerous. The drying of size is not an altogether simple business.
It really takes a good many days for a coat of one of these mixtures
to get into a state of equilibrium with the panel and the atmosphere;
and the stability of the ground will be seriously jeopardized if you
try to hurry it. It is better to allow several days more than these di-
rections call for than even a few hours less. Time is an essential in-
gredient. And it is seldom indeed that one's drawings and studies
are so perfectly in order that one cannot spend a little time on them
with advantage while these preparations are under way. The way to
save time is to make one of these waiting periods do for several pan-
els; that is, by gessoing several panels at one time, the hours and
labor may be made to go much farther. It is about as easy to gesso
six panels as one, and it can be done almost as quickly.

The intelaggio

After the second sizing, it is a good plan to fasten strips of well-washed linen cloth over the glued joints, so that if there is any shrinkage, the gesso will not give way in those parts. It is, indeed, a good plan to lay linen over the whole surface of a wooden panel; but it is not necessary, only an added safeguard against cracking.

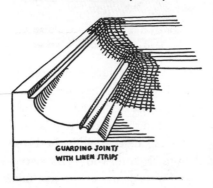

GUARDING JOINTS
WITH LINEN STRIPS

Do not try to put the linen over your moldings: it is apt to do more harm than good. The linen must be old, or it may shrink; but it must not be worn out. An old damask napkin is good. Cut it into strips, soak them in a hot solution of half an ounce of gelatine in five ounces of water, and then lay them one by one over the joints that you wish to guard, pressing them down firmly into position, and rubbing out as much of the size as you can with your fingers. After the size has set, rub over them again, to be sure that they are firmly in place. Allow this cloth coat, or *intelaggio,* at least twenty-four hours for drying, and preferably two or three days.

Puttying

Before you apply the gesso, you may have a certain amount of puttying up to do, especially on panels with moldings attached. The holes caused by countersinking should be brought up flush, and there are apt to be scratches, marks, or blemishes in the moldings and even on the flat, which should be filled up at this stage. Mix up some whiting with a little of the stock gelatine solution (one ounce of gelatine in sixteen of water), until it is about the consistency of rather soft putty. The most convenient way to mix a small amount is to put a spoonful of whiting into the palm of your hand and add the size to it there, stirring it and working it about to make a soft and rather sticky paste. Roll it up into a little ball, and as it cools it

will set, so that it can be handled quite cleanly. With a knife or spatula work this putty generously into the nail holes or scratches or other places which need puttying. Do not try to leave the surface quite smooth. It shrinks a little in drying, and so should be a little convex when it is first put on. Let it dry for at least two hours; and then scrape it smooth with a knife.

If there are no ornaments to be applied, you may proceed with the gessoing after the first size coat, if you are feeling hurried. It is better, however, to put on a second coat of size in all cases, and particularly in those in which there is to be some burnished gilding. For rush work (which does, unfortunately, have to be taken into account), the puttying may be done over the first size coat, and the second size coat omitted entirely. In this case, the putty should be mixed up quite moist and sticky; and it must always be given at least an hour or two to dry before the gessoing is started.

The simplest gesso

The gesso mixture may be made as follows. Take eight ounces of the stock solution of gelatine (one to sixteen, you will remember), and heat it in the double boiler. For this purpose, the bottom of the double boiler should contain as much water as possible, so that it will stay hot for some time after it is taken off the stove. While the size is getting hot, weigh out twelve ounces of the finest gilders' whiting, that is, an ounce and a half of whiting by weight for each ounce by measure of the solution of size.

Take the double boiler off the stove, so that the water in the bottom part will keep the size solution hot, but not too hot. Once the gesso is mixed, it must be kept as cool as it is possible to work with it. Sprinkle the whiting on to the surface of the hot size without stirring it. Simply allow it to sink into the solution. Avoid throwing in large quantities at once, or they may drag bubbles of air down into the mixture. At first the whiting will be soaked up readily; but toward the end you will find it necessary to aim the whiting at the edges of the liquid, as the pile of material soaked up rises in the center. A teaspoon is a convenient implement for sprinkling in the whiting.

Work as quickly as the soaking up of the whiting will allow you to. If the size were to get cold, you would be in trouble; but this need never happen. When all the whiting is in, let it stand until it has all become moist with size. If there is a ring of wet around the outside, and a pile of dry whiting in the center, brush the powder lightly off on to the edge of the liquid. When all the whiting has soaked up or become damp, the mixture is complete: it needs only stirring and straining to be ready for use.

The best tool for stirring the gesso is a brush. Slip your brush very gently into the mixture, and move it slowly around the sides and bottom of the dish, gradually turning the material over and mixing it; but take care to avoid beating it or getting air bubbles into it. The chief purpose of this stirring is to mix in the crust of almost solid whiting at the top with the comparatively liquid gesso below. It can be omitted; for the straining mixes the material. But it is better to stir a little, carefully. Pour the stirred mixture out into another container, and wash the brush and the top part of the double boiler.

Stretch one or two thicknesses of cheesecloth over the top of the double boiler, and fasten them there with a string or wire bound around the edge under the lip. Pour the gesso gradually upon the sieve so formed, and very gently urge it through by coaxing it with the brush. When it is all strained, remove the cheesecloth, wash the brush again, and stir the gesso with it.

The secret of success

By the time the gesso has been strained, it will probably be so cool that it will soon set to a jelly. When this happens, place it over the hot water for a moment, stirring it slowly but constantly with the brush, and it will become liquid again in a moment. *As soon as it is liquid, take it off the hot water.* Never let it stand over hot water a second longer than is absolutely necessary, or you will find your gesso full of air-bubbles, if not of worse defects. The importance of this simple precaution cannot be overemphasized.

Application of the gesso

The object in applying the gesso is to get on a fairly considerable thickness of it as smoothly and evenly as possible. There are several ways of doing this, the simplest and best, perhaps, for a beginner being to paint it out in squares, exactly as recommended for applying the size coats. If you follow this method, you will begin painting out a square with brush strokes running from left to right, and strake it off with strokes from top to bottom; and continue in this way until the whole of the panel is covered. Then for the second coat

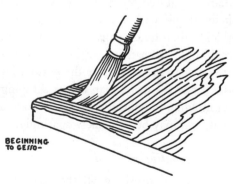

BEGINNING
TO GESSO—

begin with a square half the size of the first, so that the edges of the squares in the second coat will not coincide with those in the

first. In putting on the second coat, reverse the order of the brushing: that is, begin with strokes running from top to bottom, and strake off with strokes running from left to right. This will make your finishing strokes in the second coat cross those of the first coat, and tend to make the surface even. In the third coat, you return to the order of strokes used for the first. Normally, five coats will be needed.

Unlike the preliminary size coats, which have to dry thoroughly, the coats of gesso must follow one another as rapidly as possible. You must never apply more gesso to a gessoed panel which has had time to dry completely. The successive coats must be applied while there is still enough moisture in the previous coats to make the whole lot bind together into one uniform system. The proper moment for a second coat of gesso is when the first coat has just dried "dull" all over. When the gesso is first applied, it looks wet and shiny as you look across it toward the light. As it dries, this shininess disappears. You must wait between coats until the last trace of shine is gone; but not until the gesso is really dry. This distinction is perfectly easy to make in practice, and you will have no trouble with it.

The number of coats of gesso to apply depends a little on how thick the coats are, and also on whether there is to be any burnished gilding. For painting without gilding, a thinner gesso layer will do than is required for good burnished gold. If the gesso is applied, as it should be, with a generous hand, not excessively, but rather more thickly than house paint, and neatly, so as not to require too much scraping, five coats will make a good normal gesso for all purposes. It is always better to have the gesso a little thicker than need be on the flat of the panel than to risk scraping through to the wood; but on moldings a whiting gesso will choke up fine detail after the third coat, and may be used more sparingly.

An alternative method

Instead of brushing all the coats out in squares, these "brush coats" may be alternated with what are known as "tap coats." To apply a tap coat, the brush is filled with a generous supply of gesso,

and then tapped or smacked against the panel, while at the same time it is pushed gradually forward, away from the worker. The brush must always be moved forward, never back toward the worker. It must be kept fairly full of gesso; and the surface of the panel is to be gone over with this combined pushing and tapping motion until it is cov-ered with an even soft stipple, produced by the lifting of the brush. These tap coats possess two advan-tages: first, that they build up the thick-ness of the gesso rather more quickly

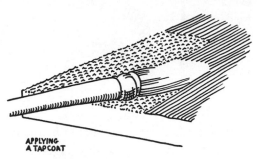

APPLYING
A TAP COAT

than brush coats, and second, that they tend to obscure the marks of the brush, and so to reduce the labor of scraping. They may be used for the second and fourth coats, the first, third, and fifth being brush coats.

It is possible to apply a brush coat immediately after a tap coat without waiting for the tap coat to dry dull. In this case, it is not painted out in squares, and not straked afterward, but simply painted on rather generously immediately after the tap coat is fin-ished. For frames and moldings, particularly, this is the best system. In gessoing a molding, take pains to prevent unnecessary choking up of the hollows and be a little extra generous with the gesso on the tops of the forms and the "points of wear." Do not bury the forms of your moldings or carvings under a shapeless mass of plaster. Re-

FORM LOST
BY CHOKING
WITH GESSO

IMPROVED BY
EXTRA GESSO ON
THE TOPS of THE FORMS

member that imperfections which would be intolerable in a plane surface will pass unnoticed in a modeled surface. Shapes can be re-stored by tooling out the gesso, but that sort of labor can be largely reduced by taking care in the gessoing.

Scraping the gesso

When the five coats, or more, or less, have been applied—all in one day—let the panel dry as usual for a day or two, the longer the

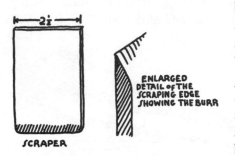

SCRAPER

ENLARGED DETAIL of THE SCRAPING EDGE SHOWING THE BURR

better. It is then ready to be scraped smooth. Begin scraping the flat of the panel. The best tool for this purpose is a steel scraper with a straight edge, two or three inches wide. This scraper may be made of a plane blade, or simply of a strip of thinnish steel. The corners should be rounded off on the grindstone, and the edge made absolutely straight across. It may then be ground sharp, with a chisel edge, and given a slight burr by rubbing the edge over toward the back against a piece of harder steel. Another way of putting a burr on it is to hold the blade vertically on an Arkansas oilstone, and rub it hard against the stone in the direction of the edge of the blade, from end to end.

How to test the scraping

Before beginning to scrape the gesso, powder some charcoal, and sprinkle it over the gessoed surface. Wipe it off with a cloth, and the gesso will be colored gray by it. Where you scrape gesso away, it will show white, and by this simple means you can tell what parts need more scraping as you work.

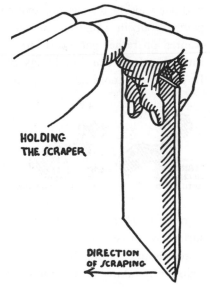

HOLDING THE SCRAPER

DIRECTION OF SCRAPING

Take the scraper in both hands, with the burred edge toward you, your thumbs

planted firmly in the middle of that side, and the ground edge away from you. Hold the blade vertically, and draw it toward you. If the edge has a good burr, it will scrape a rectangular shape of white in the gray ground. Do not try to take off too much at each stroke. Low spots in the gesso will show as gray surrounded by white, and you must work down to them gradually. The way to do this is to work around them with a sort of crisscross, herringbone motion. Do not work over one place too long, but move on and come back to it.

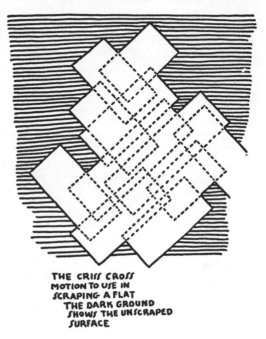

THE CRISS CROSS
MOTION TO USE IN
SCRAPING A FLAT
THE DARK GROUND
SHOWS THE UNSCRAPED
SURFACE

For scraping the moldings, you will need some curved scrapers, but not so many shapes as you might suppose; for by turning the scrapers a little from side to side they can be made to adapt themselves to various curves, flatter or steeper than those that they fit in their normal position. An old saw blade makes good stock for these scrapers. Draw the temper, by heating it red hot and letting it cool gradually. Break it or cut it into pieces of various sizes, and grind these pieces on a grindstone to curves of likely shapes, sharpening them like a chisel, and making the edge perfectly smooth on an oilstone. Then put a slight burr on them, as before, and restore the temper by heating and plunging into water. As the hollows of the moldings will generally not be burnished, they need not be made so perfectly smooth as the tops. For very quick, rough work, the tops of the moldings may be smoothed down simply by rubbing with a

wet cloth; but that is not a method which can be recommended when any refinement of form is a consideration.

Stoning down a flat

A plain panel without moldings can be smoothed down very quickly with a stone, and the result is not obviously inferior to scrap-

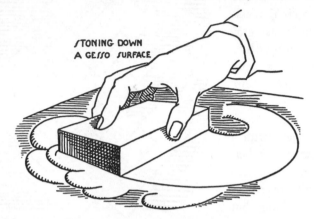

STONING DOWN
A GESSO SURFACE

ing. Take a small whetstone, say two by three inches, and dip it into cold water. Wet part of your flat gessoed surface with cold water, and immediately grind the stone over it with a rotary motion until it slides freely over the panel. Wipe off the softened gesso with a sponge or damp cloth, and treat another part of the flat in the same

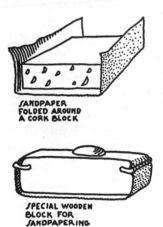

SANDPAPER
FOLDED AROUND
A CORK BLOCK

SPECIAL WOODEN
BLOCK FOR
SANDPAPERING

way. Do not work too long over any one part, or the stone may cut way through the gesso as the moisture penetrates it. The panel will dry sufficiently in a few hours to be sandpapered lightly, and will come out perfectly smooth and even. The manipulation of the stone requires a little skill; and if the slightest grain of sand or grit finds its way under the stone, the gesso may be marked very injuriously. For all ordinary purposes, however, this method is quicker and easier than scraping, and quite good enough.

Beginners are often tempted to try to smooth the gesso down with sandpaper. If the gesso is as hard as it should be, this is extremely slow and laborious. Gesso can be made softer by the use of weaker size; and this softer surface can be sand-papered down easily enough. But it is not fit for gilding, and not so good for painting. Sandpaper is useful for smoothing up after grinding with the stone. It need not and should not be used after scraping. If you use sandpaper at all, fold it around a block of cork or wood, and work over the surface of the panel rather lightly and always in straight lines. Twisted into a cone sandpaper is useful for reaching into corners and hollows which are hard to get at with the scrapers.

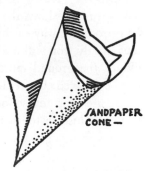

SANDPAPER CONE—

When the panel is all scraped and smoothed, moldings and all, you should take a soft sponge, squeezed out in cold water, and sponge over the whole surface quickly. This will remove all traces of loose dust, and leave the panel ready for drawing. If the work has

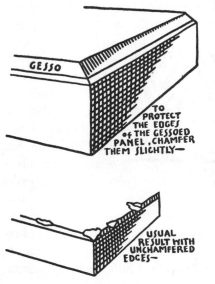

GESSO

TO PROTECT THE EDGES OF THE GESSOED PANEL, CHAMFER THEM SLIGHTLY—

USUAL RESULT WITH UNCHAMFERED EDGES—

been done well, it will be a pleasant sight, all pure, soft white, silkily smooth, as matte as cut ivory, and as crisp or melting in its contours as you have cared to make it. Chamfer the edges a little, to keep the gesso from being broken.

Qualities of good gesso

Good gesso is perfectly even in color and texture, free from gloss, unblemished by scratches, pinholes, or flecks of any foreign matter. It is so hard that it can just be

scratched with a fingernail. If your fingernail marks it without scratching, your gesso is harder than it need be; if it scratches it very easily, like so much chalk, the gesso is too soft for good gilding. Sandpapering will give good gesso a slight eggshell gloss. If it makes it really shiny, the gesso is too hard. If sandpapering makes the gesso dust away easily, it is too soft. If you have followed directions exactly, you will find that your gesso is exactly right. For good gilding, the ground must be perfect. For painting, a little leeway may be allowed; but if the gesso is not very nearly right, it should not be used for any serious painting. To take off a bad gesso, pile damp sawdust on the panel overnight, and the next day the gesso will be soft enough to scrape off with a spatula.

Pastiglia

Any patterns which you wish to work out in low relief on the panel, either under the gold or under the painting, may be executed at this point in pastiglia. This useful technique consists in building up reliefs with the warm gesso mixture, applied with a brush. It is particularly useful under gilding, as it produces rich repoussé effects; but one may have occasion to model up figures or accessories in low relief on the ground in the painting proper. To do this pastiglia, draw whatever forms you want on the smooth gessoed panel, and apply liquid gesso with a brush, until you have a sufficient body of gesso in place. It will shrink somewhat in drying; but there is generally a tendency to make the relief too high,

PASTIGLIA ORNAMENT

SECTIONS OF LINES
IN PASTIGLIA

so this is no disadvantage. When it is dry, it can be scraped and tooled to any desired degree of finish, and will give the effect of relief carving on the surface. It is a little easier to see what you are doing if you put a little bole or Indian red into the gesso mixture

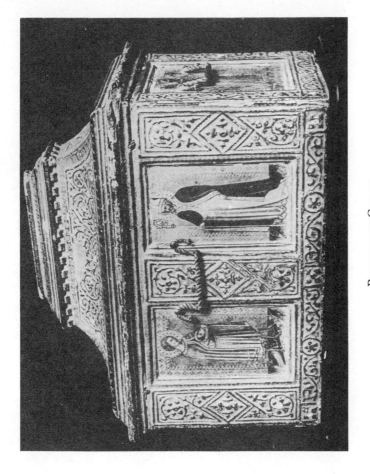

PICCOLOMINI CASKET.
SIENA, PALAZZO PUBBLICO.

with which you work out these pastiglia ornaments. If you want to make an even line in pastiglia, it is best to make a thin core at first, of the necessary height, putting on a thin line at first, and building it up with repeated coats. As each coat sets, the next may be fed on from the brush. When the central core is high enough, gesso can be flowed in at the sides to make the required width and roundness.

Gessoing frames

A word about the preparation of frames is perhaps in order here. If the frames are separate from the panels, they should be sized and gessoed in the same way. They may be smoothed down quickly and easily with pumice templets, and these are best made before the gessoing is begun. Take a piece of natural pumice, and saw it and file it roughly into the shape required to fit over the molding of the frame. It is often necessary to cut two or three pieces, or even more, to fit the separate members of a complicated molding. Lay a

PUMICE TEMPLETS

piece of sandpaper, rough side up, on the bare wood of the frame, and rub the pumice over it until it fits smoothly and exactly. In applying the gesso, put on a brush coat first; let it dry dull; and then apply a tap coat, following it immediately with a brush coat. Then take your templets and "draw up" the moldings, from end to end, so as to make the gesso as smooth and even as possible as it is applied. When this has dried dull, put on another tap coat and brush coat, and draw it up again in the same way. This will usually be enough; and when the gesso is thoroughly dry, it may be stoned down with the pumice templets dipped in water, and finally smoothed off with sandpaper. Carved frames should, of course, be scraped with tools. A little carving is often an improvement to a stock molding; and as the gesso is fairly thick, the carving may be

quite crude, and finished in the gesso with tools. Fine carving should be gessoed with gesso sottile, so as not to obscure the details.

Cennino's gesso

The process of gessoing which Cennino describes calls for different materials from the foregoing. The whiting which we have been using is a fine powder of chalk, calcium carbonate; Cennino uses calcium sulphate, which has quite different properties. Calcium sulphate is found in nature in the form of alabaster and gypsum, and from these plaster of Paris is made by burning the natural, crystalline minerals, and driving off part of the water upon which their crystalline structure depends. This roasted material, plaster of Paris, will crystallize again if it is mixed with water, and set to a familiar hard white mass. If it is mixed with size, it sets more slowly, but the resulting material is very much harder and less brittle than the ordinary plaster cast. Cennino uses this mixture of plaster of Paris and size as a basis for his final gesso, and it is an admirable material for this purpose.

Parchment size

Cennino uses parchment size, not ready made gelatine. It is quite easy to make your own gelatine from parchment, exactly as he describes, by soaking parchment cuttings overnight, and boiling them the next day until the water in which they are boiled has cooked down to a third. As long as there are plenty of parchment cuttings, it does not seem to matter just how many there are. This makes a very fine and flexible size, but it is always somewhat uncertain as to strength. It should be much stronger than the gelatine solution used for the whiting gesso: one ounce of gelatine dissolved in ten ounces of water gives an equivalent solution of the right strength.

The panel is first sized with a mixture of equal parts of this one-to-ten gelatine solution and hot water. When dry, it is sized with the solution full strength, preferably two or three times, with intervals for drying. Linen is then applied in pieces with the full strength size, and allowed to dry for several days. This series of sizings is in-

tended to penetrate the wood deeply, and to stop its pores entirely. The linen, its pores again entirely filled with size, provides a good tooth for the gesso, and insures against cracks in the wood.

Gesso grosso

Grind some pure, fine plaster of Paris with the one-to-ten gelatine solution to a stiffish paste, and apply this paste to the flat of the panel with a spatula. The best spatula for this purpose is a wooden slice, a

chisel-edged slip of hard wood. Work the gesso well into the grain of the linen, and then spread a thick coat of it over the whole of the flat with the edge of the slice, leaving it as smooth and even as possible. Then warm some of the gesso, to liquefy it; and apply it to the moldings two or three times, and pass two or three coats also over the flat which you have already done with the slice. Allow two or three days for this gesso to dry.

Cennino calls this "gesso grosso," thick gesso. It goes on thickly, makes a thick, hard, solid coating. It is rather coarse grained, and not particularly smooth, even when it is scraped down. Scrape it, however, when it is dry, and get the surface and the moldings as smooth and well shaped as possible; for the remaining operations of gessoing will not change them very much.

Gesso sottile

The next step is to apply eight coats of what Cennino calls "gesso sottile," thin gesso. The basis of this mixture is slaked plaster of Paris. To prepare it, fill a wooden tub or cask with water, and sprinkle into it a pound of plaster of Paris for each gallon of water the container holds. Stir it as you add the plaster, and go on stirring it for fifteen minutes. Then stir it every quarter of an hour for two hours. By that time, the danger of its setting will be over. Cover the container, to keep out dust, and leave it for a month, stirring it every day and adding more water if it is needed. If the water which

stands over the plaster is not perfectly clear and clean, pour it off, and add fresh every day until it becomes clean on standing. At the end of a month, pour off as much water as you can, dip some of the material out on a cloth, and wring it dry. Make it into little cakes in this way, and put them aside to dry.

Mixing the thin gesso

When you are ready to mix the thin gesso, gesso sottile, soak some cakes of this slaked plaster again in water, and grind them fine on the slab with a muller. Put the ground gesso into a cloth as you grind it, and wring it as dry as you can. Take the gesso out of the cloth, and shave it up into fine slices with a knife, putting them into the top of a double boiler. Pour over them a little of the one-to-ten gelatine solution, and mix the size and gesso thoroughly together with your fingers. Add more of the size, and continue mixing. It is a sticky business, but there is no other way. Add size until the mixture reaches the consistency of batter. It will not be nearly so liquid as your whiting gesso. Try it with the brush as you mix it, and when it works smoothly and easily, it is properly mixed.

You must take the same precautions as before against overheating this gesso. As long as it is just barely liquid, it is warm enough. Put a coat all over the panel which you have prepared with the thick gesso and smoothed down, and rub it in with a circular motion of your hand. This coat will dry rapidly, and you may then proceed to put on, as Cennino says, "at least eight coats of it on the flats. You may do with less on the foliage ornaments and other reliefs" such as the moldings; "but you cannot put too much of it on the flats. This is because of the scraping which comes next." You will find that this gesso is so *thin* that it is almost transparent as it goes on, and shows very little tendency to choke up fine detail. This thinness is a very great advantage in gessoing carvings or fine moldings, and also for executing delicate pastiglia later on; but it needs a carefully finished surface under it (which the first thick plaster provides). On a perfectly smooth wooden panel or composition surface it is possible to dispense with the thick plaster; but ordinarily it will be needed.

This thin gesso is, of course, too delicate to be ground down with the stone. It must be dusted with powdered charcoal, and scraped.

The perfection of the method

This method produces the finest possible ground for painting or gilding. It is brilliantly white, far whiter than a whiting gesso, and exquisitely smooth and perfect. It is a slower method than that which we described at first, a good deal more laborious, and for a beginner much less certain to produce a good result. It should be learned, however, by any serious tempera painter, and used whenever time and cost permit for works of any pretension. It would be pleasant always to use it; but whiting grounds are very satisfactory and will probably continue to be used. As far as technical considerations go, they are about as good as these fine plaster grounds, except where the design calls for fine carving or delicate work in pastiglia. You can work pastiglia on a bold scale with whiting gesso; but fine work has to be tooled afterward, whereas with gesso sottile it can often be worked out perfectly with the brush, and not touched with a tool at all after it is dry.

Note to 1962 Edition: If ground gypsum is available—not plaster of Paris, but the raw, unroasted gypsum—it may be used in place of whiting, in exactly the same way, and will generally be found better. Gypsum gives a crisper and whiter gesso than whiting, and is regularly used by modern gilders in Italy and France. In England, whiting grounds are more usual. —D.V.T.

METHODS OF DRAWING

Drawing for tempera

CARE and thought are necessary in planning the design of a tempera painting; but it must not be supposed that the plan need follow any traditional lines. If the fundamental design is not good, the painter will become cruelly aware of it usually even before the painting is done; but its goodness may take any kind of form. Tempera painting lends itself equally well to the rendering of the most subtle and the most vigorous designs; but imposes this inescapable condition for both, that they should be perfectly crystallized into graphic elements. The drawing may be fully naturalistic in construction and the rendering of light and shade; or it may be entirely abstract and arbitrary; it may be planned for delicate, precise handling, or for bold, loose treatment. The draughtsman has perfect freedom to draw what he will and as he will; but he must draw it definitely, and abide by his drawing. There is no room for accident or "fudging." The finished job will show all that has gone into it, and no more. It is possible to make improvements as you go along; but it is a mistake to count on making decisions about the design after the painting is begun. All the trouble and ingenuity that a designer may put into perfecting his plan will be rewarded by this uncompromising medium; and any carelessness will be impossible to hide. This is not a medium for sketching, or for unconsidered work: it is a highly developed, permanent means for final, deliberate performance.

If you lay a piece of tracing paper over a photograph of a good medieval or renaissance tempera painting, and mark around the outlines with a pencil, you will usually find that the composition is made up of clearly defined shapes which fit together snugly, like the pieces of glass in a stained-glass window, but do not blend into each other. In good stained glass, the leads make an obvious pattern, fol-

lowing the design; and in a good drawing for tempera painting, the same sort of linear pattern binds the elements of the drawing together. Of course, in the painting these outlines are not emphasized as they are in the glass; but they make themselves felt in the structure, and a great deal of the power of good work depends on the nice adjustment of these fundamental shapes. Each area enclosed by an outline is treated separately in the painting, and it

keeps some individuality even when it is fitted into its place in the finished work.

Though there is, of course, nothing to be gained by trying to reduce design to a formula, there are a few hints which may be given to the draughtsman in this connection. The beginning tempera painter will find it easier to execute the work if the individual areas of the composition are not too large. He will usually find it easier to handle the medium, at first, in a pattern made up of fairly small pieces. It is a good plan, as a general rule, to try to avoid "bottle necks" in the drawing, and to keep the shapes rather simple and compact. This is chiefly a question of ease in painting, and if a design calls for "bottle necks" or "dumb-bells" they may certainly be

A B

used; but it is often more satisfactory to break them up into two or three separate areas. Another general principle is to avoid "asterisks," the intersection of two or more lines at a point, except when they

are admitted for the sake of emphasis, to attract attention. A slight break, separation, or change of direction will keep these intersections from assuming an importance which the designer does not want.

It is sometimes helpful to remember that a certain unity can be achieved by keeping all the separate areas of the design about equal in size. The result of doing so is, of course, monotonous and dull; but if a sort of standard measure is established in the composition as a whole, it emphasizes any departures from the standard that the designer's intention may dictate. It is useful to adopt a fairly uniform standard size for the component areas which do not need to be made emphatic, so that other areas, larger or smaller than the norm, will have an effective basis of contrast.

ASTERISKS

The whole secret of using the medium effectively is to keep it constantly under control, to eliminate the accidental and substitute the deliberate. This means establishing a normal, colorless procedure at every stage, and departing from it knowingly, to produce a wanted result. The same principle may be allowed to govern the drawing. The drawing may well be whatever the draughtsman thinks is normal, natural, inconspicuous, in all parts which do not call for emphasis. In those which he wishes to stress, he may cer-

tainly employ any divergence from the standard which seems to him likely to produce the kind of emphasis he wants.

Preliminary studies

Just what studies the designer will care to make in preparation for the final painting will depend, of course, on his own judgment of what is necessary. He will find it helpful, as a rule, to plan the pattern of color and the pattern of the main disposition of light and dark values. These patterns can be studied on tracing paper laid over a small sketch of the whole composition, and the painting will generally go more smoothly if the painter has taken his decisions about color and value arrangements in advance.

There is another sort of study which is well worth making, a study of the modeling of the forms, through the use of light and shade. This can best be investigated by drawing on tinted paper with tones lighter and darker than the tint of the paper. Black and white chalk on gray charcoal paper will do, for a rough study of modeling; but there is another method, much more penetrating, and much more closely allied to the painting which is to follow, that may be highly recommended: drawing with a brush, with ink and white paint, on a pigment-coated paper.

Form drawing

This type of drawing is not much practiced nowadays, but in the Middle Ages and the Renaissance was the favorite medium of some of the greatest masters. It can be made to yield work of great intrinsic beauty, and decorative effect; and might well be revived on these accounts for its own sake. No self-colored paper can match a pigment-coated paper in beauty of material, in harmony with the material of the applied drawing, or in perfection of physical surface for

drawing. The finished work, whether it is highly studied or roughly sketched, possesses much of the material unity of a painting.

Tinted papers

To prepare the papers for this sort of drawing, first obtain a few pieces of good drawing paper, preferably hot pressed. Lay them out on a clean bench or table. They need not be fastened down at all. For large pieces, it is best to stretch the paper; but up to 11″ x 14″ or somewhat larger, the sheets can be managed quite well without even tacking down the corners. Next dissolve half an ounce of gelatine in 18 ounces of water. Then take dry powdered colors, and mix up any tone you please, making it rather lighter than you want the finished paper to appear. For this purpose, the best white pigment is zinc white. Zinc white, ivory black, opaque oxide of chromium, Venetian red, yellow ocher, French ultramarine, and raw umber, will give a wide range of fine colors; but very beautiful results may be obtained by using such brilliant colors as vermilion and cadmium yellow. Some zinc white should be included in every mixture; and it is better to have the tint too light than too dark.

When you have compounded a satisfactory mixture of the dry pigments, add a little of the gelatine solution, and stir thoroughly to mix thoroughly and break up any lumps. Then add more of the gelatine solution, making the mixture quite liquid. Then strain it through a piece of fine silk into a clean cup or bowl. Instead of using the pigments dry, you may use pigments ground with water; but it will be harder to judge the color, and there is no great advantage in having the pigments very finely ground. If dry pigments are used, the straining will remove any unground particles which might be troublesome.

Apply enough coats of this mixture of size and pigment to your pieces of paper to produce an agreeably even tone. A bristle brush is best to use for this, say a 1″ or 2″ sash tool. A slight striation from the brush strokes is often pleasant. If you want a perfectly smooth surface, you may get it by putting on many thin coats, or by stippling each coat as you put it on with a badger blender. Let each coat dry thoroughly before you put on the next. If the papers tend

to curl badly in drying, add a little water to your mixture. The advantage of not using thumbtacks to hold the papers down is that the brush strokes may be run over the edge of the paper onto the table, and the paper thus tinted evenly right up to the margins. If thumbtacks are used, the papers have to be trimmed.

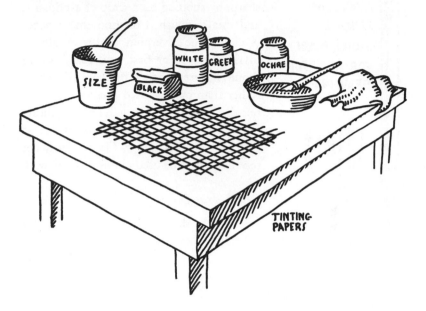

The finished papers should be agreeably colored, not too dark, and smooth and even in surface. They should be kept under a weight, or between the leaves of a book, to keep them flat and clean. If properly prepared, they will have no tendency to curl, and the color will be firmly bound on the surface.

Drawing instruments

To draw on papers of this sort, the design may be sketched first with charcoal, the charcoal then dusted off, and the drawing carried a little farther with a hard pencil, or better with a silverpoint. The zinc white in the ground gives the paper enough tooth to take silverpoint, and there is no more delicate and beautiful instrument for drawing. The most convenient and least expensive form of silver-

PROPELLING
PENCIL &
SILVER WIRES
FOR SILVERPOINT
DRAWING

point is a propelling pencil in which a silver wire is used in place of the lead. Any jeweler will supply bits of pure silver wire exactly the size of a pencil lead at trifling cost; and the ends may be shaped, blunt or sharp, by rubbing on a scrap of sandpaper, and finally polished on fine emery paper or cloth. The silverpoint makes an almost invisible mark, at first, and the drawing should be strengthened by repeated strokes rather than by increased pressure. On any but the lightest tints, it will be too delicate for finished drawing, but admirable for sketching in the design. Hard pencil, not too sharp, may be used almost equally well.

Brush drawing

When the drawing has been located with either of these instruments, mix an extremely dilute wash of India ink, say one drop of ink in a table-

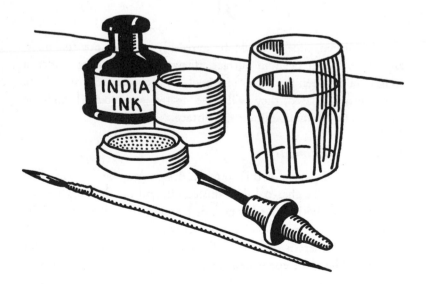

spoonful of water. Then take a fair-sized sable brush, dip it in the mixture, and squeeze it almost dry. Work over the shading with this, paying particular attention to the edge that you establish between the middle tone, represented by the untouched ground, and the shadow, which you will develop further with the ink. Plan the modeling in such a way as to make the fullest possible use of the tinted paper ground. Carry the modeling of the shadows as far as you can with this first very dilute ink. Do not try to lay a wash with it; but draw with the brush merely damp, stroke by stroke, as if you were working with a hard pencil.

Then strengthen the ink mixture a little bit, and carry the modeling of the shadows a little farther. Do not try to get the effect all at once. Do not be afraid that your drawing will be "niggling." There is plenty of time for brilliant handling later on, after the form has been found and developed a little. Keep the modeling soft at this stage, so that the shapes may be adjusted easily as the drawing proceeds. Let the form materialize gradually, like a figure approaching through mist.

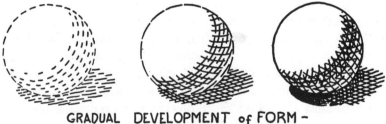

GRADUAL DEVELOPMENT of FORM –

Modeling up the lights

When you have developed the shadow modeling a little in this way, turn to the modeling of the lights. Do not try to finish one before the other. Take a little Chinese white (the water color in tubes is most convenient, or a little titanium white tempered with egg yolk, which lends itself better to the work, and looks better in the end), and thin it out well with water as you did the ink. In the same way, with the brush almost dry, work over the lights, and

establish the edge between the lights and the middle tone or between the lights and the shadow edges. Take pains to reserve the middle tone, the tint of the paper, wherever it belongs. And carry the modeling of the lights as far as you can with this first thin mixture of white. Distinguish between the half tone which results from the first thin coats of white over the tint of the paper and the solid, opaque light which comes with repeated coats.

Work back and forth in this way, from shadow to light and back again, creeping up on the form gradually, making it do exactly what you want it to do, describing it as fully as you wish; and make it a rule to go as far with each successive stronger mixture of black or white as you are able. Finally, accent the drawing, if you please, with pure black and pure white. In the final stages it is quite possible to hide all the laborious preliminaries, if you wish to do so. Brilliant finishing strokes, applied with confidence and dexterity upon a thoroughly studied preparation will remove all suspicion of "niggling," but lie securely upon the work which has been done. No two painters will employ the same approach; but even the most skilful and accurate draughtsman may benefit by the principle of finding the form inconspicuously before he renders it finally.

This sort of drawing corresponds so closely with the handling of colors in tempera painting that it should be practiced by anyone who wants to start tempera painting in Cennino's way. Cennino says that it is the way to "start trying to discover the entrance and gateway to painting," and so in fact it is. When it has been mastered, painting a panel is a much quicker, surer, and easier business.

Transferring the cartoon

When the preliminary studies are done, the drawing must be carried out on the panel. If a full-sized cartoon has been made (and it is certainly advisable for the beginner) the outlines may be taken off on tracing paper and transferred to the panel. Do not use carbon paper for this purpose, but rub the back of the tracing lightly with soft pencil, or with a little red ocher in powder. (Carbon paper usually contains soluble dyes, which "bleed through" any painting that you do over the marks it makes.)

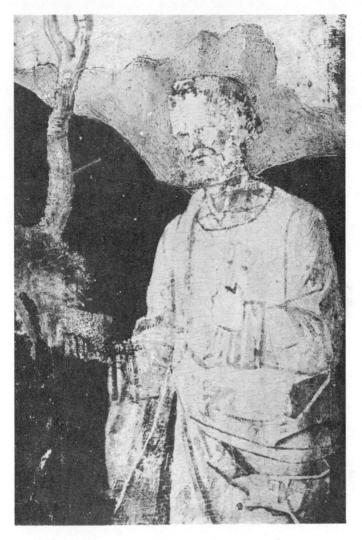

DETAIL FROM A MADONNA AND CHILD WITH SAINTS,
BY CIMA DE CONEGLIANO.

Drawing on the panel

An alternative method, excellent for the experienced painter, and much the best for large works, is to do the drawing on the panel in the first place, in charcoal. This allows of some correction and improvement; but anyone who cannot feel fairly sure of his drawing had better experiment on a separate cartoon. If the drawing is done on the panel, the loose charcoal must be dusted off, and the faint shadow which remains serves as a guide for the ink drawing which comes next. If there has been much fumbling or correcting, it will be hard to find the drawing again after the charcoal is dusted off, and the precise outlines of the tracing will be easier to work from.

Importance of the monochrome rendering

Whichever method is used for placing the drawing on the panel, what follows is the same. The outlines and modeling are to be worked up on the white gesso surface in ink. The shadows may be done exactly as on tinted paper, with a thin wash of ink on an almost dry brush, gradually strengthening the tone by the addition of more ink, and producing a smoothly modeled shadow. Or they may be wrought more boldly, with hatching strokes like a pen drawing, or any other way the painter pleases. This ink drawing on the gesso acts as an underpainting, and has a profound effect on the modeling of the shadows in the actual painting with colors. It should be carried out with about as much accuracy and finish as the painter wishes to bestow upon the final painting. Color may be used instead of ink, if you prefer. The drawing may be done with tempered pigment, black or any color, as long as the half tone and shadow values are established at least as strongly as they are to be painted.

Incising the outlines

If there is to be any gilding, the outlines of the areas of color which border on the gold should be lightly scratched into the gesso, so that they may be seen through the overlapping gold. Outlines of color against color may be scratched in in the same way, if one has

any fear of losing the drawing. An etching needle is good for this purpose; so is a graver or burin. A lithographer's scratcher, too, can be made into an excellent tool. It consists of a steel wire made up in a wooden handle like a lead pencil, and as supplied usually makes a rather coarse cut. The point should be sharpened on a stone until it is slender and fine, so that it will make a clear but very delicate scratch. A steel needle is excellent, but must be mounted for use in some sort of handle. At a pinch, a needle may just be thrust into the rubber eraser at the end of a pencil, eye first, point out; but on the whole a good etching needle or dry-point is a tool worth buying if one does much work. Do not dig the point deep into the gesso. The surface is so smooth that the least little scratch will show, and a deep furrow is disfiguring. Simply go over the outlines with the point with about as much pressure as you would exert in drawing with a pencil.

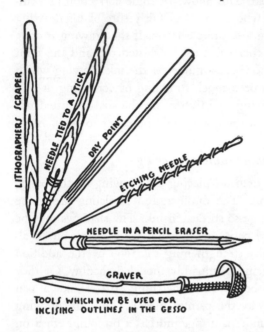

TOOLS WHICH MAY BE USED FOR INCISING OUTLINES IN THE GESSO

APPLICATIONS OF METALS

BEFORE we come to the actual painting, we may stop to consider how fields of metal may be used in pictorial design. Of all metals, gold is the most generally useful, because of its intrinsic beauty, its permanence, its convenience in application, and its associations. Silver is extremely beautiful when freshly laid; but it will tarnish eventually, in spite of every precaution. Aluminium is brittle and hard to use; it possesses little luster; it is rather heavy and lifeless in color; and its associations are for most people rather prosaic. It is not useless; but it is not an adequate substitute for silver. Palladium is better. It is lustrous and permanent, a little murky compared with silver, but on the whole, perhaps, the best white metal for general use.

Metals in the design

These metals, gold and palladium, may be applied to a gessoed panel in such a way as to make the panel seem a solid block of shining metal. In spite of their brightness, however, fields of burnished metal must be treated as darks in the design. Only when their reflecting power is increased and broken up by graining the surface may they be thought of as lights in calculating their effect. Areas of metal and color may be so arranged as to suggest that the painting has been executed upon massive gold, or inlaid in it, or enameled in the surface. Some early Italian paintings on gold grounds suggest quite strongly that their authors wanted to capture the effect of enameling in massive gold. The purist may resent this sort of deception. If so, he should avoid the use of burnished metal grounds altogether; for they necessarily produce the look of solid metal. The happiest results of burnished metals in painting design come from accepting the convention that the metal is solid, and that

it shows where solid metal might—either as a ground under the painting, seen wherever the color stops, or as a pattern of insets into the ground, or of metallic incrustations upon the ground. The conventional acceptance of gilding for solid gold is so old and so well established that it is hardly open to criticism. We are quite satisfied that picture frames should be gilded: we do not require that this innocent deception be abandoned, and the frames be made of solid gold. Many people do not want frames to look like gold at all; but that is another story.

Bole for gilding

If you want any areas of burnished gold (or palladium) on your panel, this is the way to apply them. Get some "Armenian bole," and grind it fine with water. Or buy some red burnish gold size already ground in water from a dealer in gilders' supplies. The best

bole is very "fat," and almost transparent, and warm, almost orange in color. It is sold in little conical lumps, and can be bought from any of the great English colormen. It can also be bought in hardware stores in Italy, and there costs practically nothing; but in America it is rather hard to find. American gilders usually use darker, more opaque bole, not far from the color of Indian red; and this kind does just as well. The only advantage of the warmer bole is that the color which shows through when any gold wears off is more agreeable. There are gray and yellow boles, too, and they are perfectly usable. "Gilder's Gray Clay," in fact, is a little easier to burnish than the red kind; but if there are any imperfections in the gilding, it is an ugly color that shows through. With a good red bole, slight faults are tolerable, and the effects of age and wear are often considered a positive improvement.

If you buy the bole, or gilder's clay, in the form of a paste, keep it covered all the time. If you grind the bole yourself, put it into a covered jar as fast as you grind it; for dust and lint in the bole will injure the gilding.

Mixing and applying the bole

Dissolve half an ounce of gelatine in ten ounces of water, and put a little of the solution into a clean cup. Add a little of the ground bole to it, and stir it thoroughly with a well-washed brush. The proportions of size and bole are not important. You simply want a coat of size with some color in it. A teaspoonful of bole and four or five teaspoonfuls of size is a safe rule; but the amount of bole in a teaspoonful depends so much on how wet the paste is that the rule does not mean very much.

Make quite sure that your panel is all smooth and free from dust. It is a good plan to wipe it over with a piece of slightly damp cheesecloth. Then put a coat of the thin bole mixture over all the parts which you intend to gild, lapping a little bit over the outlines which you have scratched into the gesso. You always have to gild over these outlines: it is not safe to try to gild right up to them. The best brush for putting on the bole is a red sable water-color brush. It need not be very large, even for large areas of gilding, but it must be large enough to hold a fair amount of the liquid. Apply the mixture as evenly as you can, and take pains to avoid leaving drops and trickles behind. The brush should not be too full. Wipe it off on the back of your left hand (not on a cloth) before you begin. And above all, do not try to move the bole around on the gesso after you have laid it. Put it on, and leave it. Even if there are imperfections, do not try to improve them while they are wet, or you will make them worse. If you miss any little parts, touch them in after the surrounding parts are dry, and not before. Let this first coat dry entirely, as it will do quite quickly.

Throw away the thin bole mixture, and wash out the brush. One reason for putting on this first thin bole is to wash the surface of the gesso where the bole is to come, and you may assume that the brush has carried bits of dust back into the liquid. Put some more of the ground bole into the cup, and add enough of the gelatine solution to make a rather thick cream. It should not be a paste, but a thick, creamy liquid, which will drop from the brush in large drops. It is better to have it too thin than too thick, and the exact proportion does not really matter; but a rich mixture goes on more smoothly.

The size should be liquid when you mix it up. If it has set, warm it a little. The mixed bole, too, should be warmed a little if it shows signs of setting to a jelly.

It is a good plan to strain this bole mixture through a piece of chiffon before using it; and the cup with the brush in it should be kept covered with a cap of paper all the time, except when you are actually putting on the bole. You cannot be too careful about dust, if you want to do perfect gilding.

KEEP THE BOLE & SIZE MIXTURE COVERED

How much to put on

Apply at least four coats of this bole, allowing it to dry out entirely between coats. On flat surfaces, it is best to use many thin coats, as many as six or eight; but on moldings the smoothest work is done by floating the bole on rather generously with a fairly full brush. The whole thing boils down to getting a good coating of bole on as smoothly as possible; and each workman will find his own best way of doing it, for his particular job. If you are working with an opaque bole, you may lay enough coats to produce a solid, uniform color over the areas to be gilded. If your bole is transparent, the color is not such a useful guide. In either case, four coats will probably be enough, unless they are extraordinarily thin. And if you want to be quite sure, you may put on a few more; for if you lay them evenly, they will do no harm, in any case.

Polishing the bole

When the last coat of bole is dry, the panel may be gilded. But it saves some trouble in burnishing if you polish the bole, and put on one more coat. To polish it, you may use the very finest emery paper, or better, fine sandpaper, as follows. Take a sheet of the finest 00 sandpaper, and split it. That is, strip as much of the paper off the back as you can, to make it thinner and more flexible. Then take two bits of it and rub the sanded surfaces together to wear away as

much of their cutting power as possible. The result will be a very fine soft sandpaper with which you may rub over the bole surface safely. It will grind off any little unevennesses, but will not cut through, and it will polish the surface of the bole so nicely that the burnishing later on will go more easily. After this sandpapering, you must dust off the panel thoroughly with a *linen* cloth, and apply one last coat of bole. Unless you are going to gild immediately, cover the panel with a cloth, to protect it from dust.

When you are ready to begin gilding, take a piece of soft old linen and rub over the bole quite hard, to polish it a little. You may burnish it before gilding, and it is an excellent thing to do so; but rubbing directly on the bole spoils the surface of a burnisher fairly quickly, so a special burnisher should be kept for this purpose if you wish to make a practice of it.

Gilding with glair

In place of size as a medium for applying the bole, glair may be used, as Cennino describes. It is equally good, but I think no better; and requires a little more care in wetting down for the gilding, as the glair is apt to dissolve in the water and the bole to come off on the brush. Cennino's directions may be followed exactly, without difficulty, provided one realizes that the drinking glass he speaks of is not an eight-ounce tumbler but more like a two-ounce sherry glass. Beat an egg white to a stiff foam, and pour two ounces of cold water on it. Let it stand over night, and pour off the liquid. Grind some powdered bole with this liquid glair to a stiffish paste. Mix a little of this paste with a good deal of the glair, say one teaspoonful of the ground bole to five of glair for the first coat. For each successive coat, add more of the paste of bole to the glair mixture, and put on at least four coats. The last coat will, of course, be quite thick with bole. In laying the gold, use water without alcohol, but put in a little old glair. The older glair is, within reason, the stickier it is, and the better for gilding. It is possible to build up a tolerance of the smell of stale glair; but most people will be happier gilding with size.

Tools for gilding

Gold leaf is, of course, extremely thin, and it requires three special tools to handle it easily. First, a cushion on which to cut it; second, a knife to cut it with; third, a special kind of brush, called a tip, to lift it after it has been cut. All these should be bought ready-made from a gilders' furnisher; but when this cannot be done, substitutes can be devised, as follows.

The gilder's cushion

To make a cushion, take a little panel of wood, 6" x 10", or larger, and cut a sheet of absorbent cotton of the same size off a roll. Half the thickness of the usual rolls of cotton is enough, but more does no harm. Lay it on the panel, smoothly, and cover it with a piece of leather, with the rough, inside surface upward. Chamois skin, or imitation chamois (as long as it is real skin, and not cloth) may be used instead of leather. Tack the skin around the edges of the panel, drawing it as tight as possible. This will give you a smooth, padded leather surface upon which to cut the gold. Then cut a strip of stiff, tough paper 14" x 11", and tack it around one end of the panel, so that it comes along each side for four inches, and makes a screen eleven inches high. This screen incloses a space

CUSHION

four inches long and the width of the panel, and in this you may keep a supply of gold leaves ready to be laid out on the cushion, without much fear that they will blow away. Fold the paper screen down flat upon the leather cushion, and then fold the sides over on top of it. In this position it keeps the cushion clean when out of use. To finish it off, a strip of leather may be fastened around the edge of the panel, covering the tacks, and strips of leather tacked to the bottom of the panel forming a wide loop for the gilder's left thumb to pass through, and a flat loop for the gilder's knife.

The knife

The knife for handling and cutting the gold leaf should have a blade at least ten inches long. This blade must be perfectly straight from end to end, and not too flexible. A kitchen spatula can be used, but it is not likely to be satisfactory. Even an ordinary table knife can be used; but the long, straight, rather stiff blade is a distinct

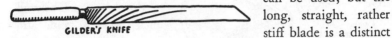

GILDER'S KNIFE

advantage. If a proper gilder's knife is not available, any knife can be pressed into service. It should have a smooth edge, but not sharp. If the edge is sharp, it will cut the cushion. To adapt a straight-edged carving knife or kitchen knife for use as a gilder's knife, it should be sharpened and then made dull by rounding off the edge on the stone.

The gilder's tip

The gilder's tip consists of camel's hair set thinly between cards. The width of the card is a little greater than that of a leaf of gold, and the length of the hair varies according to the size of the pieces which the gilder habitually uses. If he wants to take up whole leaves of gold at once, he needs a whole-leaf tip, with very long hairs; and if he is gilding chiefly small areas and lines, he will prefer a tip with short hairs, perhaps only an inch long, or even less. For general purposes, the begin-

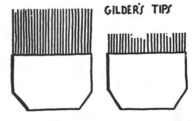

GILDER'S TIPS

ning gilder will find a half-leaf tip, with hairs about two inches long, adequate to his needs. It is useless to try to make tips for oneself, and they are almost indispensable for good work.

Substitutes

If for any reason a tip cannot be procured, it is possible to pick up the gold on a slip of white paper, provided the paper is rubbed

thoroughly over the gilder's face or hair and then pressed firmly on the gold; but this is only an emergency device, and should not be used regularly. Another, better method is to stretch a piece of fine silk net across the arms of a bow of thin bamboo. This will pick up the gold, and breathing on the net will release the leaf. The method that Cennino describes—sliding the gold leaf into place from a card with the corners

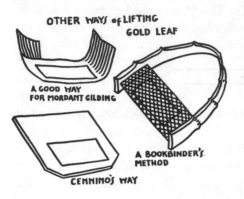

OTHER WAYS of LIFTING GOLD LEAF

A GOOD WAY FOR MORDANT GILDING

A BOOKBINDER'S METHOD

CENNINO'S WAY

trimmed off—is too hard to carry out with gold leaf of the modern commercial variety for many people to succeed with it. With thicker gold, it is possible; but the modern gilder will do well to use a proper tip, as Cennino would certainly have done if this ingenious simple instrument had been available in his workshop.

Qualities of gold leaf

The gold leaf used by medieval gilders was thicker than the thinnest modern gold, and probably in general a little thicker than what the modern goldbeater calls double weight. Heavy gold is a little easier to handle than the very thin leaf of trade; and it is worth while to buy the double weight. The cost is sometimes a little higher, as it contains more gold; but as it takes less labor to make it, some goldbeaters will supply it at about the same price as thin leaf. It is a mistake to suppose that thin leaf produces a less solid looking job of gilding. The advantage of the thicker leaf is chiefly the gilder's own convenience. He is less apt to waste gold, and imperfections in the leaf itself are less common. The ordinary gold leaf of modern trade usually contains some copper, and is often disagreeably red in consequence. Other alloys, chiefly with silver and copper, are used to produce fancy shades of gold, green, lemon, and white. With all these, there is necessarily some tendency to tarnish. Pure,

twenty-four carat gold leaf is supplied on demand by all good beaters, and unless a painter has some very urgent reason for wanting something different, he will make no mistake in adopting double-weight twenty-four carat leaf as the material of all his gilding.

Handling the leaf

Handling gold leaf is an extremely simple business, but it often takes a little practice for a beginner to learn to manage the details successfully. The first principle to remember is that gold leaf will catch and stick on anything which is even slightly damp or greasy. To avoid trouble from this quarter, the cushion should be rubbed over with a little powder of dry bole (or French chalk), and the knife stropped over it thoroughly to work the powder into the leather, and to remove any trace of grease or damp from the knife. After stropping the knife on the cushion, turn the blade upright and scrape all the loose dust away lightly. Gold leaf is put up for sale in little books of thin paper, and the paper of these books is usually dusted with red clay. Nothing is better for keeping the cushion and knife in condition than to rub them with the red leaves of an old book of gold.

To put a leaf of gold on the cushion, the safest and easiest way is to open the little book of gold to the first leaf, hold it over the cushion, and let it slide off the book on to the leather, or into the paper screen. You may take the gold out of the book with the knife, but there is more risk of piercing or tearing it. It is good practice to take the gold first from one end of the book and then from the other. This usually keeps the last leaves in better condition than going straight through the book. Be very careful to keep the book of gold dry; for if you set it on a drop of water, the moisture will often go right through it and make every leaf stick to the paper.

The use of the knife and cushion

When your leaf of gold has been transferred from the book to the cushion, you have to get it spread out flat on the fore part of the cushion, away from the screen, for cutting. There is only one right way to do this. Do not try to poke it into place. If the knife presses

against the gold, it will go through it, or else press in a crease which you cannot get out. The proper motions for the knife are these.

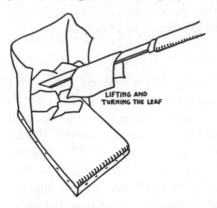

LIFTING AND
TURNING THE LEAF

First, a little tapping, flat on the cushion, to create enough of a draught to raise an edge of the leaf slightly. The point of the knife may then be passed under the gold, close against the cushion, lifting the gold slightly as it goes, until it comes out on the other side. Second, lifting the gold clear of the cushion, with a little shake, to make it unfold as much as it will. Third, a slow, smooth turning, which lays the gold out again on the cushion the other side up. The edge of the leaf is brought against the cushion, its outside (as it hangs across the knife blade) against the leather, and the rest of the leaf is then unwound by the knife. This is a very simple and easy operation, and it is the whole trick in handling gold leaf. Every time the gold is picked up on the knife, it must be put down the other side up.

When you have turned the gold over in this way, you can blow some of the wrinkles out of it. If you blow straight down upon the cushion, into the middle of the gold, your breath will tend to flatten out the gold. If you blow sideways, particularly toward the edge of the leaf, you will blow the gold right off the cushion, into the air. (If you do, don't try to catch it! Let it fall where it will, and then pick it up with the knife, if by good fortune it has fallen on a dry place.) Pick the gold up on the knife again, roll it off on the

cushion, blow into the middle of it, and repeat these operations until it lies exactly where you want it on the cushion, spread out smooth and even, without wrinkles. The most tangled leaf can be straightened out quickly and easily in this way, provided the tangles are not made permanent by pressing with the knife. Lift, turn, and blow, is the rule, and there are no exceptions. It *never* pays to try to push the leaf about, or to straighten out one corner by itself. Lifting, turning, and blowing all take a little practice, and a skilful gilder can unwind a shapeless little pile of gold in fewer motions than the beginner, because he knows from experience just where to lift, just where to turn the gold off the knife onto the cushion, and just how to blow the wrinkles out with a smooth, *crescendo* breath into the heart of the tangle.

After you have got enough practice to feel confident about handling the gold, you will spill a dozen leaves or more at one time into the screen at the back of your cushion. This saves a great deal of time, and makes the actual gilding go much more smoothly. The gilder who tries to lay his gold out on the cushion flat out of the book never learns the skill in handling leaf which this labor-saving method requires. The good gilder does not want to stop his gilding to take gold out of the book any oftener than he has to, and a dozen leaves, or two or three dozen, are perfectly safe on the back of his cushion.

When a leaf has been laid out neatly on the fore part of the cushion, and blown down firmly with a breath, it may be cut into two pieces, or any greater number, with the knife. Lay the knife straight across the leaf where you want to make the cut. Sight it, and bring the edge of the blade down firmly on the leaf. With very light pressure on the blade, push it a little away from you, and then draw it straight toward you across the leaf. The result will be a clean, true cut, with no pulling or ragged edges. Half leaves, "threes," or "fours" are best for beginners to apply. With these, the cut leaf may be left in position on the cushion, and the outside portion taken off with the tip as required. But if you cut into "quarters," with two crossing cuts, and want to lift one of these "quarters," it must be separated from the rest. The quickest way is to lift them all back

into the screen, and then take one up with the knife, turning and blowing it, as if it were a whole leaf, into position at the front of the cushion. But "quarters" are wasteful at best, of both labor and gold; and it is better to use the whole width of the leaf. After one half has been used, the remainder may of course be cut into two "quarters" as readily as into "fours," but at least the first cut from a leaf should ordinarily be used without any further cutting.

The use of the tip

The leaf is lifted and placed in position on the panel by the gilder's tip described above. To make the gold adhere evenly to the hairs of the tip, the hairs must be given a thin coating of oil, by drawing the tip over the face or hair. If one's skin and hair are abnormally dry, a trace of vaseline may be rubbed on the cheek; but this is not usually necessary. Lay the tip against your hair or forehead, and press it down firmly with your left hand, drawing it out slowly with your right hand. Turn it over, and repeat the operation. Do this several times, if necessary, to make the hairs of the tip lie smoothly and sleekly straight. During the work of gilding it may be necessary to treat the tip this way again; but usually it is enough to draw it lightly across your hair or face. This motion, which a gilder performs almost automatically, is often supposed to be made with the idea of electrifying the hairs of the tip. This is erroneous. An electrified tip makes gilding almost impossible; for the gold leaps off the cushion as the tip approaches, and cannot be controlled. Even gilders themselves sometimes believe that they dust the tip across their hair to electrify it; but an experiment with a dry, ungreased tip will con-

vince them of the contrary. Tips should be kept between the leaves
of a book when they are not in use, to keep the hairs in order.

To pick up the gold with the tip, hold the tip just over the piece
of gold that you want to pick up until you see that the edge of the
hairs is parallel with the edge of the gold, and just a little back of it.

Then press the tip down with
a steady motion upon the gold,
and lift it off the cushion. You
will find that the gold adheres
firmly to the hairs all over, ex-
cept for a thin edge—say an
eighth of an inch, or less—
which projects beyond the
hairs. If the gold does not ad-
here to the hairs, press the gold
and tip together lightly against

the cushion. If it still does not adhere, the tip is not sufficiently
greasy. When the tip is in good condition and the gold carefully
picked up, this delicate material can be moved about through the
air with perfect security and placed in any position.

Laying the gold

With the gold picked up on the tip, you are ready to begin the gilding proper. Put four ounces or so of cold water into a clean glass, add about an ounce of ethyl alcohol, and stir it well with a good-sized sable brush. With this brush, wet a section of your bole-covered surface considerably larger than the piece of gold which you want to lay. Get it thoroughly wet, and take pains not to rub the surface of the bole with the brush any more than necessary. When it is wet, bring the tip with the gold up close to it, holding it parallel with the panel surface, and sighting the position which it is to occupy. When you have got it directly over the right spot, move the tip toward the wet surface quickly but steadily, and equally quickly move it away again. This motion may require a little practice. It is almost exactly the motion which one uses in testing a hot iron with a wet finger—a touch, and away; but steadiness is important, and the tip must be kept flat, or the gold may be broken.

Some gilders prefer to gild a panel flat, others to tilt it up for gilding to an angle of sixty degrees. The advantage of tilting is that the gilding liquid (water and alcohol, or plain water) may be fed *under* the gold leaf as it is laid, by bringing a wet brush just up to the edge of the leaf. This flowing water behind the leaf causes all the wrinkles to flatten out, and enables a skilful gilder to manage with less gold. The beginner seldom succeeds with this method. If the flow of water is not kept up constantly, the gesso begins to dry, and the channel closes; water breaks through the gold, instead of staying underneath, and the advantage is more than lost. Keeping the panel flat is generally best for beginners; but it may occasionally be worth while to tilt it up either to drain off any excess of liquid which has collected, or to flow water under any piece of gold which may have gone on badly, so as to float it out on the surface of the liquid.

Assuming that the panel is being gilded flat, the wetting just keeps a little ahead of the gilding. You lay one piece of gold, and then wet the ground for the next piece. In wetting for the second piece, it is a good idea to run the brush just a hair's breadth over the edge of the gold already laid, so that the overlapping portion of

the second piece will stick to the first. The same end may be accomplished by breathing rather long and slowly on the space to be gilded immediately before applying the gold. Moisture will then condense on the gold already laid, and the overlap will stick to it. These overlappings usually show a little in the finished gilding, especially as it ages, and they are worth taking a little trouble. Furthermore, since they tend to show, it is desirable to have the pieces of gold carefully cut and neatly applied. Large areas of gilding should be made up as far as possible of uniform pieces, and any odd-shaped bits of gold should be kept back on the cushion for the final faulting.

The order of gilding

To insure perfect contact between the gold and the bole ground, each leaf should be pressed down with a piece of cotton soon after it is laid. The right time to do this will be learned by experience. If the water is still standing under the gold on the surface of the bole, the pressure of the cotton may force it through the gold leaf, and cause an ugly blemish. If the ground has dried up, pressing with the cotton will do no good. The right moment is when the water has run off or soaked into the ground, and before the ground has begun to dry. In practice you will usually find that this means laying a leaf and then pressing down the second leaf back, or the third or fourth leaf back, according to the speed with which you work and the generosity with which you wet the surface.

Lay the gold in some regular system, in rows from left to right, and top to bottom, ordinarily. This reduces the danger of dropping liquid on the gold which has been laid, and makes for economy in all the operations. Do not try to cut gold too carefully. Begin by making sure that you cut pieces large enough, if you have a certain space to fill. It takes less gold to put on one piece too large than to put on one too small and have to add another to fill it out. Do not try to fit your gold up to too many other pieces. You can fit a piece into one right angle with perfect certainty; but if you try to make it fit two or three right angles, there is grave danger that it will not fit any of them, and you may have to put on two or three pieces to

make it come out right. Cut the gold neatly and carefully, but be as generous with it as the saving of labor may require. Remember that the smaller you cut it, the more of it goes into overlaps, and the more it will take to finish the job. If a piece goes on badly, it is often better to take it off with a wet brush and put on another than to try to repair the first.

Faulting

When you are getting the ground gilded, do not pay too much attention to any little faults or breaks or omissions in the gilding. They are easily repaired after the main work is done. If you happen to have a scrap of gold to fit a fault, you may put it on, certainly; but stopping to fault (as repairing of this sort is called) disturbs the tempo of the gilding, and slows down the work. It is better to postpone the faulting to the end. If you have accumulated a lot of little scraps of gold in the back of your cushion, they may be used for faulting. Otherwise, cut a leaf into narrow strips, and each strip into such little pieces as you find you need. Then, either with the tip or with a brush handle wrapped in a wisp of absorbent cotton and lightly moistened with your lips, pick up these little squares of gold, one by one; and set them in place upon the panel, breathing on the surrounding gold until it is damp from condensed moisture, and pressing each little patch down promptly with a bit of cotton. Obviously, in a warm room it will sometimes be impossible to rely on condensation, and you will have to wet the place for each patch slightly with the brush; but when you can do it with your breath alone, it makes a neater job.

Burnishing

The panel is now gilded; and it must be covered with a clean cloth and set aside to dry before it can be burnished. It seems to do no harm to dry it, at this stage, in a gentle draught, even of warm air. Hot air, directly on the surface, will make it crack; and no doubt the more gradual the drying, the better. In America, in a steam heated studio, an hour or two is sometimes enough to dry

gilding for burnishing; while in England, in winter, the gesso is sometimes too soft to stand the pressure of the burnisher after two days of drying. It is desirable to burnish as soon as you can do so safely; but the advantages of burnishing early are not by any means equal to the disaster caused by burnishing too soon, and it is a good plan to allow a generous time for drying. If you tap the dry gesso with a burnisher, it gives a sharp click. When you tap a piece of fresh gilding, still damp, it gives a dull sound; but as it dries the result of tapping changes back to the sharp click. This is perhaps as good a test as any; but it does not guard against the possibility that some spots may be damper than others. The only safe precaution is to begin burnishing so carefully that if there is a damp spot, you will not be pressing hard enough to make a serious mark.

Varieties of burnisher

The burnishers commonest in modern trade are made of agate or flint, and they are perfectly satisfactory. Cennino's were made of hematite for the large sizes, and of animals' teeth for the small burnishers. Hematite burnishers are still made, to some extent, for book-edge gilders, and the edge-gilder's burnisher is exactly what one wants for burnishing the flat of a panel—a broad, straight, thin burnisher mounted on a strong handle, long enough to reach your shoulder. With this you can apply the pressure necessary to produce a really perfect burnish. Failing this, almost any burnisher, except the little points made for china painters,

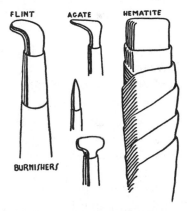

can be made to do; but the straighter the burnishing surface, the more beautifully metallic you can make your flat of gold.

As soon as you decide, by tapping, that the gold is ready to be burnished, take a burnisher, and work lightly over the gold with a circular motion and no positive pressure at all. The point of this is

to detect any little grit or roughness, and damp spot, or danger of that sort, and to get the surface a little bit inclined to take the harder burnishing later on. It is not a bad plan to rub a little beeswax (genuine!) on a piece of soft leather, and wipe the gold over gently with this before you burnish. The slight trace of beeswax which this leaves makes the burnishing a little easier, and also a little safer; but it is not at all necessary.

Follow the first rotary very gentle burnishing by a somewhat harder burnishing, with the strokes all running one way. Do not let the strokes of the burnisher be random, but work over the whole surface with one kind of stroke, running in one way. Then, increasing the pressure slightly, burnish the whole surface again with strokes running another way, perhaps at right angles to the first, perhaps at other angles. The effect of this sort of regularity in the burnishing is not apparent until it is done; but it is an important part of good gilding. Of course, on carved portions, or pastiglia ornaments, you will burnish according to the form. Pastiglia can be shaped up and improved by the burnishing, to some extent. It should be burnished entirely. Carved ornaments, on the other hand, are often burnished partially, on the tops, as if they were of dull gold polished on the tops through wear. Burnishing should be carried as far as it will go. This means coming back to it a few days later, and putting on the final burnish after the ground has set really hard. The first burnish always goes a little dull, and needs to be gone over in this way. Any imperfections in the gilding which appear during the burnishing can still be repaired by breathing on the surface, laying fresh gold, pressing down with the cotton, and, after a moment, burnishing.

Stamping and graining

The panel gilded and burnished, it remains to speak of the possibility of embellishing the gilding further, and strengthening its metallic quality, by the use of impressed ornament. This served an important purpose in Cennino's day; for the haloes of the saints were distinguished in the gold grounds of paintings by tools pressed or beaten into the gold. The plane surface of burnished

gold is something like a mirror. It looks, for the most part, uniformly dark or uniformly light. If it is broken up in parts by the use of stamps, the parts so treated possess different properties of reflection from the plane surface, and tend to look bright when that looks dark, and vice versa. Haloes were swung with compasses, which pressed thin circular grooves into the gold, and they were then ornamented with lines pressed in with a stylus and with

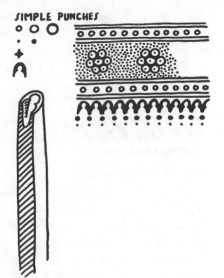

SIMPLE PUNCHES

figured punches. These punches were generally simple: rings of various sizes, points to correspond, sometimes clusters of points or rings, and occasionally some fancy forms, floral, or geometric, or architectural. These simple elements were combined with great ingenuity into beautiful and appropriate patterns.

Punch cutting

If a modern painter feels that he can make good use of this branch of technique, it is not difficult to make tools for the purpose. No modern application of this kind of work has been attempted by painters, except in imitation of the old, and the field is open for invention and experiment. It is a simple matter, given a length of brass rod, a vice, a hack saw, a metal file, one or two needle files such as jewelers use (round, square, triangular, etc.), sandpaper, emery cloth, and a few bits of tool steel for counter-punches, to manufacture punches of any design. To make a ring punch, for example, you simply file a sharp round point on a steel rod, and polish it with a strip of emery cloth; cut a three-inch piece off a brass rod; and drive the steel counter-punch into the end of the brass rod far enough to make the center of the ring punch of the right diameter.

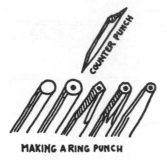

MAKING A RING PUNCH

Take the file, and file away the outside of the brass rod an inch or so down from the point until the ring is left on its face in the proper thickness. Polish the end with sandpaper and emery cloth, and shape it exactly with the file and those abrasives. Test it by holding it in a smoky flame and pressing it on white paper which you have damped by breathing on it. You can make the tiniest ring graining tool in this way, for making an all-over grain on the gold, or large rings to be combined in ornaments. Other tools are made in much the same way. For some, a steel burin will be needed to cut out the pattern. For complicated tools, if they are wanted, you may need to arrange a magnifying glass over the vice; and this is easily contrived with a chemist's flask holder and stand. It is almost necessary to make the tools yourself; for leather workers and bookbinders, who use tools of this sort, want only much larger, coarser elements than are good for this purpose.

These punches are most conveniently made, as described above, on short rods (whether of brass or steel makes no difference); for to apply them to the gilded surface, you strike them sharply with a flat strip of hard wood, and no handle is required. The smaller the face of the punch, the lighter the stroke it takes; while a large or complicated punch may need a powerful blow to press it into the gilded gesso.

Graining pastiglia

Pastiglia ornaments are much improved and made more effective if the elements of the design are outlined with a line of dots, and the background grained. Cluster tools for graining are tempting, as providing a quick effect; but they are never so satisfac-

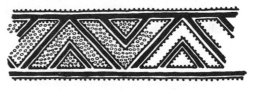

GRAINING BEHIND PASTIGLIA

DETAIL FROM THE SANT' ANSANO ANNUNCIATION, BY SIMONE MARTINI.

tory as the single tools. I favor the use of a very small ring punch for putting a uniform grain over an area of burnished gold, whether as a background for pastiglia ornament or designs drawn in the plane surface with a stylus, or as a ground to be used in combination with color in the following way.

Patterns in color and gold

If you lay over a field of burnished metal a solid coat of opaque or transparent color, tempered with egg as if for painting, and let it dry, you can scrape away the color with a wooden point and show the gold underneath; and you can form in this way any pattern of gold and color you please. When the color is properly tempered, it comes away as smoothly and neatly as an etching ground, and in very much the same way. An orange-wood manicure stick is a good tool to use for this work; and the color which is left on the gold should be given either a coat of weak size, or one or

SCRAPING
COLOR OFF GOLD

two coats of charcoal fixative, or very weak shellac, to keep it from being rubbed off accidentally.

An inscription in gold on a field of color can be executed easily and beautifully in this method, or figures of any sort in gold and color. It is often applicable to the rendering of textiles, figured or threaded with metal. Large-scale patterns of color and gold are, of course, simply executed with the brush after the gilding is done, and the edges trued up with the wooden stylus. But the use of this *sgraffito* method may be extended widely. You may, for example, lay a ground of white on the gold, and take out certain fields with the wooden point, leaving a pattern in white and gold; then glaze the whole pattern with viridian, and take out part of it again in gold with the point. This will produce a pattern in white-glazed-green,

gold-glazed-green, and gold. The decorative possibilities of this method are largely unexplored in modern times, and should be worth investigating.

In practicing it, it will usually be found that the gold which is uncovered, though bright, is not effective as gold in the small areas in which it is exposed. If the uncovered portions are grained, "frosted," with a small ring punch or other tool, they catch the light and sparkle, and play a much more striking part in the design. By graining them in some parts, and leaving them flat in others, these areas of gold surrounded by color can be given a wide variety of agreeable effects. When gold and palladium are used together in the underlying ground, the range of effects of color and metal is, of course, still further increased.

Burnished metals in the scheme of painting have been used in the past with great success; and there are some indications that the modern painter may find new ways to make good use of them. Tooling the surface of these areas of metal is a natural consequence of their solid appearance. The use of pressed-in and stamped-in ornament develops their power of reflecting light, gives them variety, and forms a legitimate addition to the elements of the design. This sort of ornament increases the illusion of thickness in the metals, and makes it still more urgent that these metallic surfaces be used by the designer as if they were not leaf but massive gold and silver.

Still further resemblance to massive metal results from the process for producing damascene effects invented by Professor Lewis York, and reported by him in *Technical Studies in the Field of the Fine Arts,* II (1933), 105, 106. Professor York's original paper is reprinted here, with his consent, by permission of *Technical Studies.*

COMBINATION GOLD AND SILVER LEAFING

When a figure in silver is wanted on a gold ground, or conversely, both metals to be laid in burnished leaf, sharply separated, good results may be obtained by the following process. First lay and burnish the silver leaf; then paint over the already burnished silver with a rubber cement up to the edge desired. When the cement is dry, the gold leaf is laid over the whole area enclosed within the outline formed by the edge of the cement. When the gold is laid, it should, of course, be allowed to overlap the edge of the cement itself.

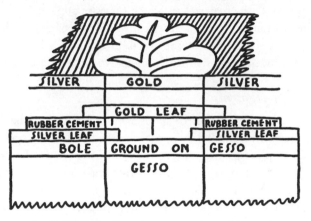

As soon as the gold is ready to burnish, the rubber cement and excess leaf can easily be rolled up into a little ball with the finger, leaving the gold in the desired pattern on the ground of silver and ready to be burnished.

Various applications of this method may suggest themselves—backgrounds figured in the two metals, patterned draperies, armor, inscriptions, etc. When silver leaf is used it will tarnish unless protected by a lacquer of some sort. In certain cases the effect of the darkened silver in contrast to the unchanged gold may be utilized to good effect. When this is not desirable, a permanent burnished silver quality may be obtained by the use of palladium leaf, which has lately become available in commerce. The color of palladium differs somewhat from that of silver: it is a little dark and leaden in comparison, but only a very critical eye will detect the substitution.

PIGMENTS AND BRUSHES

THE most obvious essential for any kind of painting is a set of brushes. A pigment is a colored solid which can be held in place by a binding medium. It is usual to distinguish between pigments and dyes, dyes being soluble colored substances which penetrate the material to which they are applied, and alter its color by combining with it physically and often chemically. Pigments, in the strict sense of the word,' are simply held in place on the surface by the adhesive medium in which they are applied.

Function of pigments

The simplest illustration of a pigment is perhaps to be seen in mosaic. Each little colored cube may be regarded as a pigment particle held in place by the cement in which it is set. In the ordinary sense of the word, of course, the separate particles of a pigment are small; and instead of being set in the binding medium, as they are in mosaic, the pigment particles in most painting systems are completely immersed in the medium, and surrounded by it. Ordinarily a pigment for painting is a very fine powder; but this is not always the case, and even a fine powder, examined philosophically under the microscope, proves to be made up of separate bits which may be compared with the separate tesseræ of the mosaic painting.

Natural and artificial colors

In the Middle Ages, it was customary to distinguish between natural and artificial colors. The most obviously natural colors are, of course, the earths and minerals. The most obviously artificial colors are the products of laboratory chemistry. It is not always easy, however, to make such sharp distinctions, and even in the Middle Ages classification into these groups could seldom be carried out completely. Cennino speaks of colors which are natural "but need to

be helped artificially." In point of fact, though nature has been generous with colored materials suitable for use as pigments, very few of them indeed occur ready for use without some special treatment; and it is not to our advantage to preserve this distinction between natural and artificial which the Middle Ages took over from Pliny.

The colored earths

We may, however, begin our consideration of pigments with a glance at the colored earths. Everyone knows the appearance of colored earths in nature; but the red and gold and purple of new-ploughed fields, the mellow browns of well-tilled soil, are not readily adapted for painting purposes. These colored earths owe their colors partly to the presence of strongly colored salts of iron, manganese, and so on, resulting from the alteration of ores of these metals, and partly to organic matter, resulting from the decay of roots and leaves and wood; but these coloring elements are much diluted in most natural earths with little-colored clays and sand. They look quite dark and bright when they are wet, but they dry out generally quite weak and dull. It is only an earth which contains a very high percentage of the decomposed ores of coloring metals, such as iron, which will yield a good earth pigment. The slow action of air and water and organic acids breaks down the hard structure of the mineral ores, and turns them into powder, which we call ocher. The red earths and the yellow earths, the hematites and limonites of the geologists, are largely made up of oxides of iron, more or less hydrated, and more or less combined with other salts. The sand and clay and humus that they contain must be washed away to make them fit for pigments.

This washing is important, not only to produce a good, strong color, but also to insure its permanence. Some samples of raw sienna contain enough organic matter to cause them to mold in tempera, to swell on the panel, and eventually to come away. Naturally, the less washing a native earth requires, the better it is for the pigment-maker; so the red and yellow ochers of the painter tend to be made from the richest deposits of hematite and limonite-colored soils, from relatively few localities. One such locality, Sinope in Pontus

(Asia Minor), was the great classical source of red earth, and this place-name has survived in the English color-name, "sinoper," meaning reddle or ruddle, a red earth rich in iron oxide.

There is enormous variation in the color of these natural earths. The reds range from the warm pink of Pozzuoli red (from the soil of Pozzuoli, in the bay of Naples) to the deep, almost purple red of certain Persian and English ores which are sold under the name of Indian red. What is called "English red" is usually a yellow ocher which has been turned brick-red by roasting. Venetian red usually means a fairly light, warm red ocher. The natural earths are very far from uniform in color, and the color merchant often has to secure the uniformity that his clients demand by blending several earths together. The medieval painter took his natural ochers as they came, and made the most of any special character they might exhibit. If he got hold of a bright, warm earth red, he might put it aside for making flesh tones in fresco, and use it for that only, until he found a better pigment for the purpose. If a sample turned out dull and poor, he might still be able to find uses for it in some minor capacities, such as drawing on the wall, or underpainting for other colors.

Yellow ochers are no more standard in nature than the reds. We can sometimes buy a light ocher and a dark ocher, and sometimes one or two special qualities besides; but these do not by any means reflect the useful range of natural yellow earths. The green earths, too, called "terre-verte" in trade, are far from uniform in nature. They vary from bright apple green to dull olive, and include two distinct mineral classifications, celadonite, which yields the bright Verona terre-verte, and glauconite, the source of the "Bohemian" terre-vertes, which run the gamut of yellow greens and olives.

Individual pigment characters

In modern painting methods, subtle differences in the characters of pigments tend to be submerged. In oil painting it does not make very much difference in the effect whether the painter uses an earth red in its natural register or forces a bright red down in key to match the earth red in color. Modern oil paint has so much mate-

rial in it besides pigment that the pigment hardly has a chance to show its individual character. In medieval painting methods, however, the separate pigments tend to be exhibited with emphasis, almost like jewels in a complicated setting. Fine colors were so hard to come by in the Middle Ages that the painter would not willingly degrade them by indiscriminate mixing. The palette was treated almost like a collection of precious stones, to be grouped in the painting with as much regard for their intrinsic beauty as possible. And the media in which they were applied gave full play to the individualities of the pigments; for they were unobtrusive in themselves. Medieval writings assume a regard for pigment characters, an interest in the fatness or leanness, coarseness or fineness, transparency or opacity, of each separate pigment; and even for its source, as a matter of significance to the collector. The medieval painter was as aware of the special qualities of his particular colors as a musician of the special qualities of instruments and voices. He tended to use his pigments in their natural register, modifying them simply and systematically according to established practices based on their known behavior.

Pigments in tempera show their natural characters plainly, and it is worth while to know a good many of them before settling down to the use of any one palette. It is worth while to buy small quantities of respectable pigments from different sources, as opportunities arise, and to select the ones which suit best your personal tastes. It is possible to go a long way with a very simple palette indeed; but it is a pleasure and an advantage to possess a group of pigments selected for their intrinsic beauty and their harmonious relationships. Chance may bring some fine ochers your way, quite different from the ordinary standard trade varieties, like the bright pink or deep purple-red earths which occasionally turn up in small lots; or the unusually bright or rich yellow ochers that one sometimes finds. Vermilions are by no means standard, and you may have use for the scarlet shades and also for the deep, almost violet sort that you can sometimes buy. There is a great range of quality even in cobalt blues and ultramarines, from greenish to violet, and from bright to dull.

Experimentation

It is not wise to buy pigments from doubtful sources unless you mean to test them, or to have them tested; for purity and permanence cannot safely be judged by superficial examination. But among the artists' colormen of unquestionable integrity, the standards of blending for different pigments vary; and many manufacturers are willing to supply ungraded samples of pigment from stock which has not been made up to their standard specifications. A friendly colorman once furnished me with a set of six or eight raw umbers ranging from the deepest olive brown to almost cocoa color, all of them pure and genuine; but in his published list he offered only one raw umber, the same year after year. It is the merchant's pride to maintain these uniformities; but it is not always to the artist's best interest. When you find a pigment that pleases you, it is a good plan to buy a generous stock of it. A difficult taste in ochers cannot be satisfied on the spur of the moment, and when a good chance comes it is wise to take advantage of it. Try colors out in as small samples as you please; and when you are especially pleased with one, buy a pound, or five pounds, or as much as you can, so that when you want more you will not be disappointed. If you buy from doubtful sources, you must get tests made, for safety's sake. It is not worth while for a painter to try to test his colors for himself; and as a general rule his best plan is to avail himself of the stocks and knowledge of the established colormen. They will usually welcome inquiries for choice pigments of special quality.

Palettes for tempera

The basis of a palette for tempera is a selection of opaque colors. For ordinary purposes, the transparent colors are on the whole less useful, and should not be used except where their special qualities are actually desired. Actually, this is even more true of oil painting than of tempera; but the slovenly habit of mixing up transparent and opaque colors at random, with no thought of their natural characters, has become so common that many oil painters do not regard it as bad practice. In tempera, raw sienna is less generally use-

ful than yellow ocher, burnt sienna than English red. The opaque oxide of chromium is more often useful than viridian; and cobalt blue works on the whole rather better than the artificial "French" ultramarine. The transparent colors, the siennas, viridian, aureolin, the red lakes, Prussian blue (if it be used at all), and so on, should be kept in reserve for use where nothing else will do, and not introduced casually into mixtures.

Whites

Almost every mixture in tempera will contain at least a little white, and it follows that white is the most important single pigment in the palette. It must be selected with care. The classic white pigment is white lead, and it is still in some ways the best of all. It is heavy and dense, extremely opaque, and a little goes a long way. For crisp, loaded finishing strokes, it is unequaled by any substitute; and for the ordinary run of painting it works a little more agreeably than anything else. It is perfectly permanent when varnished, and does not at all deserve the bad character that chemists have tried to give it. Under unfavorable conditions, when not varnished, it is sometimes darkened by sulphureted hydrogen in the air; but this effect seldom or never takes place in practice, except with water colors or gouache. Even when it does occur, it is not unduly serious; for it tends to correct itself automatically by oxidation of the black lead sulphide to white lead sulphate, a process which can easily be encouraged by exposure to hydrogen peroxide.

There is, however, a serious objection to the use of white lead in any water medium, and that is its poisonous nature. In oil, the risk of poisoning is very slight, because the oil holds the particles of white lead together, and only gross carelessness can account for an artist-painter's getting lead into his system from using this pigment. In tempera, however, one deals with white lead powder. It is ground simply in water, and it may dry out and be inhaled. It may get on a cigarette, or under a fingernail. In tiny quantities, it may find its way into the body in many ways. Once in, it tends to accumulate there, and infinitesimal amounts often repeated may in time build up a dangerous total. This danger is not imaginary; and it is very

hard to guard against. If white lead is used, even on a small scale, one cannot take too earnest precautions against getting even a trace of it into his system. I consider it somewhat better than any other white pigment for tempera, and indispensable for oil; but I do not feel that its superiority in tempera is sufficiently great to warrant taking the trouble necessary to use it safely.

Instead of white lead, therefore, the tempera painter will be well advised to use a titanium white. Titanium lithopones, compounded from titanium and barium, are brilliantly white, opaque, permanent, and entirely adequate substitutes for white lead in tempera. Zinc white is not. Zinc white is bulky and disagreeable under the brush; it lacks tinting strength, so that you have to use a great deal of it to make other colors lighter, and hiding power, so that you have to use many coats of it to get a solid effect. Titanium white, on the other hand, is only a little more bulky than white lead, and beautifully dense. It gives clean, sharply defined value gradations, paints out pleasantly, and leaves an agreeable surface. It requires little or no grinding, unlike white lead, which requires a great deal.

Blacks

Next to white, in tempera, black is perhaps the most useful of pigments. It has been the fashion for some years to condemn the use of black paint on the ground that there is no black in nature. Actually, I think, the origin of this prejudice is probably the ugliness of black prepared as an oil color in the modern way. There is nothing objectionable in some of Goya's blacks, certainly. But commercial oil paint black has neither luster nor fluidity in itself; and as an element in mixtures often tends to sully the color. In tempera, however, black and white yield fresh and beautiful grays, and the range of neutrals which may be made with them can be used to good advantage. The mixture of complementaries to produce neutrals, so much in vogue among oil painters, may well be forgotten by the tempera painter; for he can produce more satisfactory results by simpler and more economical means. He may use black as much or as little as his color scheme calls for, without fear that it will make his color muddy. He will find that lampblack, an insufferably dirty color in

oil, is an exquisite instrument in tempera, yielding a series of grays quite different from those he gets with ivory black; and those in turn quite different from the series which vine black, blue black, gives. They are all useful. If you want only one, choose ivory black.

Yellows

For yellow, to begin with, get a good ocher, and make it go as far as possible. That is likely to be surprisingly far; for in tempera yellows look stronger than they really are. This is so true that one can seldom use much of a yellow brighter than ocher without having it look out of key. Have a little middle cadmium on hand, but keep it in reserve, and do not use it until you find that ocher is really not bright enough. You may want a little of the stronger yellow in your mixed greens; but even there be careful! The great beauties of tempera are the cool, pearly, light, blond tones, which one cannot get in oil; and they have the effect of making even a dull yellow seem quite bright. Strong yellow or yellow green is apt to look rank in their company; but this is, of course, a matter of taste and judgment for each painter to settle for himself by experiment. There is no objection to bright yellows on grounds of handling. Chemically, middle cadmium is probably the most permanent.

Cennino had a yellow brighter than ocher, called "giallorino," but we do not know with certainty what it may have been. We know that at least two pigments went by this name, one a sort of yellow glass or frit, and the other, massicot, a yellow oxide of lead; but Cennino's giallorino may not have been either of these. There is only this against its having been massicot, that Cennino says it can be used in fresco; and we should not think it good practice to use massicot on fresh lime. Cennino's pale, bright yellow was orpiment, not unlike pale cadmium in color. Orpiment is a sulphide of arsenic, and extremely poisonous. Cennino did not regard it as very important for panel painting; and a modern painter will certainly do better to use the safe cadmiums instead, as far as bright yellows are needed.

Reds

Among your reds, you will almost certainly want a vermilion;

and it is worth while to take some trouble to get a sample which suits you. The best Chinese vermilion is cold, pure red or very slightly violet, and rather more generally useful, perhaps, than the scarlet or orange tones of the cheaper vermilions; but they are all worth having. The way to judge a vermilion is to try it out in mixtures with white; for this brings out its character more fully than any other test. Vermilions are made by two different methods, and those made by the process used in Cennino's time are usually called "Chinese" vermilion in modern trade. They are somewhat better than the others, probably a little more inert chemically, and a little less likely to be darkened by sunlight. Any vermilion that you buy from a reputable colorman, however, is quite sure to be well made, well washed, and permanent enough to be used with an easy conscience. In America and Europe, the adjective "Chinese" is not intended to deceive. In China, in Tientsin, I bought a vermilion, beautifully packed and supposed to be of the highest quality, which owed no small part of its beauty to sophistication with an aniline dye. It pays to deal with a merchant of known dependability. Vermilions are expensive, and are frequently adulterated by second-class merchants. It is not worth while to grudge the cost of the finest qualities; for a little goes a long way, and it may as well be the best. If you have trouble in getting dry vermilion wet with water, add a drop or two of alcohol.

There is a modern red which looks a good deal like vermilion until you mix it with white, called cadmium red. It should really be called selenium red; for if there were no selenium in it, it would just be cadmium yellow. It is a useful color, and perfectly permanent. It does not take the place of vermilion, but makes a useful addition to it. Red lead, too, may be used quite safely if the color is wanted. The modern pigment is made by a different process from that used in the Middle Ages, and is redder, less orange, and on the whole less useful. It cannot be recommended; but it is quite reasonably permanent.

Among the earth reds there is so much useful variety that it is difficult to choose. One might start with a Pozzuoli red, a Venetian red, and an Indian red, and add others from time to time. It is ex-

tremely convenient in tempera painting to be able to mix a given tone with as few different pigments as possible, so as to be able to match it easily later on; and the less one's pigments are mixed together, the more their intrinsic beauty appears. So there is some advantage in having a palette selected for your special taste and needs. One painter may want a dozen earth reds, from the pinkest Pozzuoli to the deepest caput mortuum, with burnt ochers, like "light red" and English red, and the Mars browns and violets as well. All these are good, and the selection is purely a matter of taste. Differences among these colors are much more clearly marked in tempera than in oil.

Browns

Browns are not likely to be wanted in very much variety; but the umbers, both raw and burnt, may be included, and burnt sienna for a redder tone. Raw umber, particularly, is a useful pigment for some color schemes. Cennino mixed his browns, out of black and white and yellow and red; and called the mixture "verdaccio." The word verdaccio means a nondescript greenish color, and that is just what Cennino's mixture produces. Black and white and yellow ocher give olive greens, and adding a little earth red turns them into greenish browns. Adding more red kills the green, of course; so presumably Cennino's verdaccio covered a range of brown to olive. It was not a definitely fixed color. A good olive raw umber saves the modern tempera painter a good deal of mixing.

Blues

The blues that Cennino speaks of are not generally available for modern painters. It is possible to buy genuine ultramarine, made as Cennino describes, from one or two English manufacturers; but it is extremely expensive, and few painters nowadays have the medieval enthusiasm for costly materials. It is rather significant that they have not; for it reveals as clearly as anything else the decline of the pride of craftsmanship in painting. A goldsmith could execute most beautiful designs in tin or imitation gold; but he would consider it

beneath his professional dignity. Nickel could be substituted for platinum in jewelry, and no one would know the difference. Artificial ultramarine is almost as much like genuine ultramarine as nickel is like platinum. Time was when painters shared with goldsmiths a feeling of pride in the nobility of the raw materials with which they worked; and this feeling was, of course, fostered by the noble purposes that their paintings were to serve. Cennino, in Chapter LXXXXVI, argues that it is *good business* to be liberal with precious materials, as well as becoming to one's dignity as a painter, and acceptable in the eyes of God and the Virgin. I am not at all sure that his argument is not still fundamentally sound. I am not at all sure that it would not be good business nowadays, and bracing to his self-respect, for a painter to use materials of some intrinsic worth, not because they were necessary, but because they were valuable. It would not make bad painting good; but it might have some good effects.

Cennino's other chief blue, azurite, is not offered in trade nowadays. It is no good in oil or water color, and so it has been dropped by the manufacturers from their lists. In tempera it is extremely beautiful, and highly individual. It is absolutely permanent in itself in tempera; but if it is surrounded by oil or varnish, as it may become, if it is insufficiently tempered, it turns black or green as the medium darkens. It is a troublesome color to paint with; for it must not be ground too much. And to get it at all, one must buy the mineral azurite, pound it, grind it, wash it, and grade it himself. There is no difficulty about doing this. Azurite stone can be obtained through Ward's Natural Science Establishment in the University of Rochester (N.Y.). Ward's supplies the very beautiful Arizona azurite to color manufacturers in Japan; but as far as I know, no artists' colorman in America or Europe offers the finished pigment for sale. Few modern painters will wish to take the trouble of grinding and washing the mineral; and cobalt blue makes a fair substitute.

Cobalt blue is an admirable pigment, perhaps, as I have said, more useful in tempera than artificial ultramarine. It is important to get a good quality, and the best grades are expensive as modern pigments go; but the cheap grades are worthless, or adulterated. A good deal

of ultramarine passes for cobalt in cheap colors. There is no objection to cerulean blue as a pigment, and there are some other blues which may be used if they are wanted. Indigo is one of these. Its color is not likely to make it widely popular in these days; but anyone who wishes to use it in tempera may do so without much fear for its permanence. In thin washes, in water color, it fades; but in tempera it stands up well.

Greens

The terre-vertes are good colors in tempera, and their transparency makes them peculiarly valuable in underpainting flesh. Verona terre-verte is the choicer, and a bright sample will prove extremely useful, alone and in mixtures. Another mineral green, malachite, a brilliant green copper ore, is most beautiful in tempera. It has, unfortunately, shared the fate of azurite. It can be bought as a pigment from one or two firms; but is invariably too finely ground. If you want it, you must buy the mineral, grind it, and wash it, saving the medium-fine particles, those which settle out of the washwater in five or ten minutes. It is hard to paint with, like azurite; for it is rather coarse and gritty. But, like azurite, it is inimitable. Azurite is useful even when finely ground; but malachite turns very pale and dull if it is reduced to anything like the fineness of other pigments.

Modern chemistry has given us a most valuable pigment in the opaque oxide of chromium, which supplies an important lack in the medieval palette. Opaque oxide of chromium is much less known and used than its near relative, viridian, the transparent oxide; but its importance will eventually be recognized. Viridian is enjoying nowadays much the same sort of vogue that Prussian blue enjoyed eighty or a hundred years ago. It is a very strong, self-assertive color, and so beautiful in itself that it is often allowed to dominate a great deal of modern painting. Like Prussian blue, it tends to infect the whole picture in which it is used; and, also like Prussian blue, it becomes monotonous. It is a most valuable invention, replacing verdigris; but it has been greatly abused. Much of its beauty is its transparency; and this is often wasted. Viridian is often used in opaque mixtures which could be produced more economically

and more soundly with the opaque oxide of chromium as a basis. Both these chromium greens are useful in tempera; but the tempera painter will do well to reserve viridian for positions in which he really wants it.

Transparent pigments

Besides viridian, there are several other transparent colors which are sometimes wanted: first, the red lakes. Cennino believed in lac lake, a violet red called "Indian lake" in modern trade, and seldom offered for sale. He knew brazil wood lakes, and grain lakes, and did not think highly of them. He did not, apparently, know the madders, or their synthetic counterparts, the alizarines. For the modern painter, these are the soundest red lakes to use. They are not absolutely permanent, but they are quite permanent enough for use. The madders age a little more agreeably than the alizarines; and as the latter are very strongly colored, the true madders are often more pleasant for glazing. Rose madder may be taken as the normal representative of the natural lakes, and alizarine crimson, of the artificial. Red lake glazes are useful and beautiful in modeling over other colors, especially over white, gray, and vermilion. Viridian is useful in the same sort of capacity, especially for modeling on white, yellow, and green. Transparent yellows, such as aureolin, which corresponds roughly in modern practice with Cennino's arzica and saffron, are useful chiefly for taking the chill out of these green glazes. Gamboge should not be used in tempera. Raw sienna is not likely to be of any special service, unless perhaps in painting hair, and may be omitted from the tempera palette without much hardship. Burnt sienna is quite transparent, and may be used. There is no serious objection on grounds of permanence to Prussian blue, if an absolutely transparent blue is really needed. As we shall see, even the most opaque colors can be made to give effects of relative transparency in tempera, and the transparent pigments are generally best kept in reserve.

Shell gold

Among Cennino's pigments we must count powdered gold. This

is used pure, over grounds of color, and sometimes mixed with the color in varying degrees. Used by itself as a pigment, it can be made to yield most brilliant and decorative effects. The lights on a blue drapery, for example, can be modeled up entirely with the pure gold, and the effect may be very fine. For small quantities it is convenient to buy the powder ready-mixed with gum, like a water color. It is sold as shell gold. One, two, or three little drops of gold paint are placed on a mussel shell, reminiscent of the shells in which the painters and illuminators of the Middle Ages used to mix and keep their colors. If you plan to use much of it, it is a good idea to buy the gold

SHELL GOLD

powder from a gold beater, and mix it yourself as you need it with a little weak solution of gum arabic or with white of egg prepared as described[1] for gilding.

The choice of a palette

The list of colors which one may use in tempera is long. The number that one needs, however, for normal practice, is small. If you have these eight—Titanium white, ivory black, yellow ocher, vermilion, alizarine crimson, Indian red, cobalt blue, and opaque oxide of chromium—you can go a long way without feeling short of material. That is not to say that this limited group of pigments will satisfy everyone. You may want to add cadmiums and viridian at once, or terre-verte and Pozzuoli red. If you definitely want a certain pigment effect, get the pigment, and do not be put off with a degraded mixture of other pigments. Venetian red cannot be matched in tempera by toning down vermilion. Too many Procrustean palettes have been published of late years for me to add another to the list. The wise tempera painter will experiment with many pigments, sound in themselves, until he finds a group which suits him. He can compose a dozen good and useful permanent palettes without using any of the colors on this list, and each group will have a different character, which the painting will reflect.

[1] P. 55, above.

Grinding the colors

Pigments are usually sold in the form of powder, and before they are ready to be used for tempera painting they need to be ground with water. Fine as the powders seem to be, most of them are not fine enough to paint with without further grinding; and all of them need intimate mixing with water, whether they are fine enough or not. Grinding one's own colors has a romantic sound; but I do not set any particular store by it. It is a laborious and messy business; and a friendly color manufacturer will generally consent to grind

SLABS & MULLERS

colors in water at no great extra cost. If, however, you wish to grind them yourself, you must obtain a slab and muller. The best material for these is, as Cennino says, porphyry. Failing that, granite is good. Porphyry and granite implements, however, are usually extremely expensive; for they have to be made to order. A marble table top will do for a slab, and a small lump of marble for a muller can be got out by a stonecutter at small expense. Simplest of all, however, is to buy a glass muller from a dealer in scientific laboratory supplies. It should have a three-inch grinding surface, and you will

want a piece of ground plate glass about eighteen inches square. The glass or marble will wear down, and have to be resurfaced; but they serve well enough for grinding any but very hard pigments.

To put a good edge on the slab and muller, take some medium fine emery powder and throw it on the slab. Wet it to a thin paste with water, and grind it round and round, with a slight rocking of the muller, hardly more than a little extra pressure on the nearer edge. Wash off the emery, and grind your pigment in the same way, mixed with water to a thin paste. It does no good to *stir* the color with the muller: it must be ground. You will soon develop the knack of keeping color between the grinding surfaces and off the sides of the muller. Add water as you need to, while grinding, to keep the right consistency. The muller should move freely, but the pigment must be fairly creamy or pasty, or it will not be ground properly.

For gathering up the color after it is ground (and there is no rule but experience for how long to grind each color) you scrape it up into a little heap, and put it into a color jar. For this you will want a small wooden slice, a strip of hard wood cut like a chisel at one end.[2] This is much better than a spatula, and enables you to clean the slab up almost perfectly, with almost no waste of the ground color. After grinding, wash the slab immediately, with a sponge and warm water and soap; and if it is not perfectly clean, grind some emery powder on it again.

Storing the ground colors for use

For keeping the colors after they have been ground, it is desirable to have wide-mouthed bottles with air-tight covers. The color is put in in the form of a paste, and the bottle filled up almost to the top with water. It must never be allowed to dry out, or the color will become granular and have to be reground. It is not a bad plan to use rather small bottles, grinding only a small amount of color at a time. You do not use any great amount of pigment even in a large painting, and there is less danger of contamination if the supplies of

[2] As illustrated on p. 37, above.

color are renewed from time to time. If you buy your colors ready ground in water, it is advisable to transfer a little of each from the manufacturer's containers into small bottles of this sort. From a druggists' supply house you can obtain excellent little two- or four-ounce wide-mouthed bottles with screw covers made of bakelite.

GROUND COLORS UNDER WATER

Tin covers are less good, because they often rust. The bottles should not be more than half filled with the ground color, so as to leave plenty of room for water above. Small quantities of fresh color are much more convenient than large jars which have collected dust and traces of other colors, and I recommend the two-ounce screw-cap bottles for ordinary use. It is convenient, though not necessary,

RACK FOR COLOR JARS

to have a box or stand to hold the color jars, so that they are always in order, and kept from tipping over. A length of two-by-four with sockets cut in it to fit the jars makes a satisfactory rack for them.

Dishes for mixing

For mixing the colors in painting, nothing is better than the nests of porcelain color cups used by architects. It is an advantage to

have a generous supply of them; two dozen is not too many, though you can do with less. The covered porcelain trays with eighteen or twenty-four cup-shaped hollows in them are also useful; and for small paintings

one or two of these do just as well as the more costly sets of color cups. For large works, that is, for panels of more than six or eight square feet, it is a good plan to buy a generous supply of small white bowls; or cheap, heavy whisky glasses will do well enough, and cost less.

The choice of brushes

The choice of brushes for tempera painting will be regulated to some extent, of course, by the size and type of the painting; but whether the brushes are large or small, blunt or pointed, bristle or sable, they must be designed to hold a certain body of color and to feed it out in painting as freely and smoothly as a pen feeds ink. This means that the hairs or bristles must be fairly long, and nicely toed in to the point, so that the natural curve of the hair forms a reservoir between the ends. Nothing is better than red sable water-

color brushes. It does not pay even to experiment with camel's hair; it is too soft and unmanageable. Black sables are a little less expensive than the red, but much inferior, not only in the hair, but usually also in the workmanship. Curiously enough, breadth of treatment in tempera has not very much to do with the size of the brushes. You can work as minutely or as broadly as you please with a small brush; and for the beginner, small brushes are usually an advantage. Japanese or Chinese brushes, made of fiber or sheep's hair, are of limited usefulness for tempera painting. They make beautiful strokes with very thin color; but have not enough spring for general use.

Sables

It pays to buy the best brushes, and to take good care of them. Fine English-made brushes of red Russian sable are very costly, but extremely good. Some American makes are now equally satisfactory. One pays a good deal for the nicely finished handles and nickel

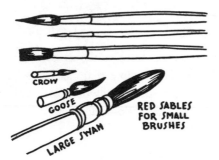

ferrules of good water-color brushes, however, and it is a great economy to buy the brushes in quills. Beautifully made sables in quills, used in America chiefly by sign painters, cost much less than the finished artists' brushes, and are every bit as good. One must, of course, take the trouble to soak the quills for a while in warm water, to soften them, so that they will not split and break when the handles are pressed into them; but that is a small matter.

Anyone who does much tempera painting will want to keep on hand a good supply of these brushes. It is good practice to use a fresh brush for each mixture as you paint; and if this is to be done, two or three dozen brushes will often be in use together. It is not necessary: you can do the whole job with one brush. But it is a much better plan to use many brushes, so that the tones are kept

separate, and you do not need to be washing out your brush constantly as you work. And the brushes will wear down more slowly and evenly. Three dozen brushes bought at once will outlast three dozens bought separately, and give better service. If possible, build up a good stock of brushes quickly, and add a few every once in a while, so that your supply gets a little better all the time. When not in use sable brushes should be kept in a tin box with a few flakes of naphthalene.

Brushes should ordinarily be round. Flat brushes are not so useful as one might expect. They make a broad stroke, it is true; and it might seem as if they would be quicker for laying in a tone. Actually, they are not. They do not hold so much color as round brushes; and though the stroke is broad, it is often not even. The size of brushes, too, is apt to be a little deceptive in this matter of speed. Large sable brushes tend to lay a coat thicker, but not necessarily faster. So much depends on neat manipulation that a skilful painter can lay in a tone with a small sharp pointed sable faster than a careless painter with a much larger and apparently more suitable tool.

Bristles

For broad areas, however, it is obviously unsuitable to work with a small sharp point. For large pictures, it is valuable to have some good bristle brushes; for they can be made with a broader, blunter point than the sables, and so produce a stroke better proportioned to a large scale of detail. It is not easy to obtain suitable bristle brushes, however. Artists' oil brushes are, for the most part, worthless for tempera. Up to the middle of the nineteenth century, oil colors were generally used fresh, ground by hand, with a good proportion of oil, and were in general fairly liquid. Brushes in those days were designed to hold enough of this liquid paint to make a long, smooth stroke. When colors began to be ground by machinery and packed in tubes, and kept, the proportion of oil was soon reduced; for manufacturers found that the pigments settled out of the oil, and their patrons complained. Cutting down the amount of oil did not solve the difficulty, and it was found necessary to put in wax and other materials, such as alumina and aluminium stearate, to

keep the color in suspension and to make it "set up." This sort of oil paint, however, did not flow from the brush. It had to be pushed into place on the canvas. And consequently the form of artists' brushes changed. Long bristles were a nuisance in handling this soft, plastic material; and round brushes spread it less neatly than flat brushes. The artist's bristle brush has changed within a hundred years from a pencil to a spatula. The thin, flat, straight, short-bristled brushes which are common today are as different as possible from the plump, long, springy brushes of the eighteenth century. There are, however, fortunately a few brush-makers who still offer well-made brushes with a good length of bristle.

Bristle brushes for tempera should be round, and very long in the hair in proportion to their diameter: as much as two inches of

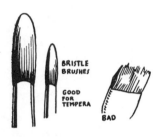

BRISTLE BRUSHES

GOOD FOR TEMPERA

BAD

bristle is not excessive in a brush the size of a lead pencil, or a little larger. For the point to have any shape, a brush of this sort must be made from bristles of high quality, carefully graded, and accurately toed. This means that it must be expensive; and brushes of this sort are expensive. But with care and washing, they will last a lifetime, and pay rich dividends in satisfaction. They improve with use, and the more they are washed with soap and water, the better. The points may be rubbed with sandpaper or emery cloth if they do not give a smooth stroke; for the "flag" (the divided end of the bristle) is of no value except as an indication that the brush has not been made from cut bristles.

Care of brushes

Do not make the mistake of supposing that you can let tempera color dry in a brush and wash it out afterward without injury. Tempera colors turn quite insoluble after they dry; and if they once harden in the neck of the brush, around the ferrule, it will not be long before the hairs begin to splay and break. Wash your brushes after use with mild soap and water, and take particular pains to squeeze the color out of the neck. Wash the soap out thoroughly,

and dress the point nicely. If you take good care of good brushes, they will last for years; but if you do not, they can easily be ruined in a week. Do not try to repair a brush injured by abuse. If the point is winged, so that it makes two lines instead of one, throw it away. If stray hairs stick out, leaving a gap in the arch of the brush, throw it away. If the hairs break off at the ferrule, and the brush accordingly loses its spring and its capacity, throw it away. Do not give storage room to a brush in bad condition. Painting in tempera with a poor brush is exactly like trying to write with a broken pen—it cannot be done well.

PAINTING

Mixing the tempera

TAKE a raw fresh hen's egg, and crack it on the side of a bowl. Lift off half of the shell, keeping the yolk in the lower half, and letting the white run into the bowl. Pass the yolk back and forth from one half shell to the other several times without breaking it, so as to get rid of as much of the white as possible; and pinch off between the shells the little white knots which adhere to the yolk. Put the yolk into a cup, and break it, stirring up with it one or two tablespoonfuls of cold water. It does not much matter how much water you add; a little more or less makes no difference. You will probably develop a preference for a thick egg mixture or

a thin one as you get used to it, and either is all right. The main point of adding the water is to cut the greasiness of the yolk a little, and make it fairly liquid. Pour it into a four-ounce, glass-stoppered, wide-mouthed bottle.

Preservatives

It is a good plan to add to this egg mixture two or three drops of vinegar, or of 3 per cent acetic acid. This has the effect of making the mixture less greasy, and a little easier to use. Some yolks are very oily indeed, and they are made more liquid by adding this weak acid. The acid does no harm, and more may be used; but if there were any great excess of it, it might injure ultramarine blue, and it is therefore just as well to use only a little. This acid has a slight preservative action on the yolk of egg; and no other preservative should be used. Oil of cloves or eugenol is often recommended,

but they are objectionable. Sodium benzoate is used in some commercial temperas, and perhaps does no positive harm; but the egg mixture will keep for several days in a cool room without any preservative at all, and it is better to replace it every two or three days than to try to keep it going longer.

It is a good plan to have two tempera bottles, and to transfer the unused tempera from one to the other at the end of a day's work. The used bottle can then be washed with soap and hot water, and rinsed with boiling water, to destroy the organisms of putrefaction. The use of two bottles in this way prevents the formation of hard crusts of egg on the inside of the bottle and around the neck. These crusts are very hard to remove; and when they are allowed to remain, the tempera usually tends to spoil quickly. Tempera was once called "la pittura *al putrido*," but this nickname need not be deserved. A little care and forethought will prevent any trace of unpleasant odor about the studio.

The mixture of egg yolk and water is your tempera, the binding medium which holds your colors in place on the panel. It is added to the colors which have been ground with water, and the process is called tempering. The composition of the tempera may be varied in innumerable ways, and some very valuable properties may be given to it which egg yolk alone does not possess; but there is no better single all-purpose tempera than the plain egg, and it is advisable for any tempera painter to master the discipline of this basic medium before he experiments with others.

Tempering the colors

Tempering the colors is often the hardest part of this technique to learn at first. There is no formula for it; because every pigment and pigment mixture needs a different amount of tempera. With care and practice, a skilful painter can produce a beautifully even, velvety, matte surface without fear that any part of it may be insufficiently tempered. But this surface beauty is lost when the painting is varnished, and it is therefore hardly worth the trouble and risk that it means to a beginner to achieve it. His safest rule in tempering colors is to add enough egg to every mixture to make it a

little bit shiny when it is first painted out and dry. In this way, he may be quite sure that he has enough tempera in his colors. It is better not to have any great excess; but any excess is better than the least deficiency. If there is not enough tempera, the colors will dry out unevenly, usually lighter than expected, the paint will pile up unpleasantly, and the painting will have a chalky appearance. Furthermore, when it is varnished, any parts which have been insufficiently tempered will turn dark and spotty. If care is taken that each mixture dries with a slight gloss, the values do not change in drying, the paint goes on smoothly and easily, the gloss will disappear in a day or two; and when the painting is varnished there will not be any unpleasant surprises.

The process of tempering is extremely simple. A little of the paste of ground color is placed in a color cup, and about an equal bulk of the egg yolk medium added to it. It is stirred with the brush, thoroughly; and the tempering is then tested by making a stroke or two on a gessoed panel, a little block of plaster of Paris, or a lump of natural raw umber. Let the trial strokes dry for a moment or two. If they are dull and chalky, add a little more egg to the mixture, and try it again. If they dry very slowly, and come out very shiny, try adding a little more of the ground color to the mixture; for the proportion of egg is probably unnecessarily high. The perfection of tempering is to produce a mixture which just does not shine when dry; but to achieve this, one must run a grave risk of insuffcient tempering, and it is not worth while. Too much tempera will make the painting greasy; but even that is better than the chalky look of colors too little tempered. Aim at a slight gloss; add more tempera if you find a color drying dead; and you will soon find what sort of mixture gives the best results.

Reserves of color

It is a good plan always to mix your colors first without tempera, and to keep a reserve of the untempered color, in case you add too much egg to the rest. The color cannot be kept long after it has been tempered, hardly, indeed, from one day to the next. But any mixture can be kept on hand indefinitely before the egg is added as long as it

is not allowed to dry up. Since it is not easy to match the color mixtures exactly, it is a help to keep a little of each important mixed tone that you use, in case you want to return to it later on to make some change. Do not try to temper too much color at a time. Keep the untempered mixture by you, and add the egg to portions of it as you need them. The tempered color should be stirred with the brush every time the brush is filled, so that it will keep the same constitution until it is used up.

Liquidity of the mixtures

It is easier to test the correctness of the tempering while the tempered mixture is fairly thick and creamy; but when you come to paint with it, the tempered color should be thinned out well with water. It is very important that the color should be thin enough for the brush to move perfectly freely over the gesso. There should be no feeling at all of pushing or dragging about it. This is hard for the beginner to realize, particularly if he has been used to painting in oil. It is actually quicker and easier to build up an even tone with thin coats. Thick color dries slowly, and if it is touched again with the brush while it is still wet, makes unsightly spots, uneven in color and surface; while with thin, well-diluted paint, the brush skips quickly back and forth over an area, building up any desired amount of solidity, a little at a time, but without delays, and very easily.

Handling the color

The secret of ease and expedition in tempera painting may be summed up in one simple formula—Get your tempering right, keep your color liquid, and have your brush squeezed almost dry. In a word, make haste slowly. Tempera painting is as far from the technique of the water color on the one hand as it is from the plastic paint-pushing of oil handling on the other. It is much closer to the technique of pencil rendering; and the tempera painter will do well to bear that comparison in mind, and handle his brush as if it were a pencil. When you want to lay a tone in tempera, do not try to

float a wash, and do not try to spread the paint out with the brush; but run over the area to be covered with quick, easy strokes, like pencil marks. Follow this first coat with a second, applied in the same way, running the strokes perhaps at a little different angle, according to the form; and continue in this way until you have built up as deep and even a body of color as you want.

If the color is thick, the brush will not work like a pencil. It will not move freely, or make an even stroke. You must add water to the color until it offers no resistance to the free movement of the brush. If the brush is simply dipped into this liquid color, it will make very wet strokes at first, until the excess liquid is used up. The ends of these strokes will show as little blobs, and it will be impossible to keep the tone even. A good brush has a certain natural capacity, depending on its size, and within the limits of that capacity it will feed liquid color down to the point as evenly as a good fountain pen. If you will dip your brush into the liquid color, and stir it thoroughly, and then wipe the excess color off the brush, first on the edge of the color cup and then either on a cloth or on the back of your left hand, you will find that it will give a whole long series of uniform strokes; and you can paint with it with as much control as you can draw with a pencil. This perfect control of the stroke is, of course, much more important in modeling than in laying flat tones; but it should be practiced from the beginning. A careless painter, to get an even tone, is obliged to put on coat after coat, and to blot out the ground and drawing with a thick mass of paint; while a skilful painter can establish an even tone with less labor and more luminosity by laying the color neatly as he goes. At the end, for accents and strong modeling, you may want to apply some drawing strokes with quite thick paint; but the preliminary work is best done thinly.

Basic principles of tempera painting

In the application of the tempered color, it is necessary to understand and apply the optical principles which govern the behavior of colors in tempera. Regardless of the pigments it contains, no well-tempered mixture is absolutely opaque; and, as each mixture ordi-

narily contains some white, it is not absolutely transparent. Its opac-
ity and transparency are relative, and are conditioned by the values
over which the mixture is applied. If it lies over a lighter ground, it
appears transparent. Light strikes the paint, passes through it, strikes
the lighter ground, and is reflected back to the eye through the layer
of paint. Some light has been lost in surface reflection, some has
been absorbed in passing through the paint film in each direction,
and some has been absorbed by the ground. But as long as the
ground is lighter than the paint, it will reflect some light back
through it, and produce an effect of transparency. Any color in tem-
pera laid thinly over a lighter ground will act as a glaze.

When the coat of paint lies on a ground of equal value with itself,
or on two or three coats of similar color and value superposed, the
surface underneath it is no more reflecting than the paint itself.
Light passes into the paint layer and is reflected according to its
color and value, and the effect produced is of opacity. Any color in
tempera can be made to look opaque by putting on repeated coats of
it. If, however, the color lies upon a ground darker than itself, the
ground, instead of reflecting
light, or having no effect upon
it, absorbs part of the light
that the layer of paint trans-
mits. The color appears darker;
and, being composed of a sus-
pension of finely divided parti-
cles, it takes on a cloudy,
smoky quality which may be
called "opalescence." This qual-
ity, to which, in nature, the sky
owes its color, and mist or
smoke against dark objects,

GLAZE & SCUMBLE

their blueness, stands half-way between opacity and transparency.

Control of form

The basic principle of tempera painting is control, control particu-
larly of this relation between color values and transparency. By de-

veloping the design in intermediate tones, intermediate both be-
tween the extremes of light and shade, and between the extremes of
opacity and transparency, the tempera painter acquires perfect con-
trol over the expression of his forms. Keeping in reserve his strong-
est lights and darks, and establishing first over the whole region of
half tone, shadow, and reflected light a
set of opalescent tones, tones neither
transparent nor opaque, but convertible
toward either at his will, the tempera
painter is able to govern the modeling
of form with as much precision as he
wishes.

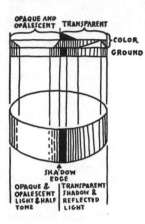

The function of the monochrome drawing

The whole composition is worked out
in monochrome on the gesso surface of
the panel, the modeling indicated ordi-
narily by lines or washes of ink on the pure white of the gesso. By
painting over this shading with tones always somewhat lighter than
the parts of the shading that they cover, the half tones and shadows
and reflected lights in the drawing are automatically converted into
opalescent tones of paint. In practice, three values of color over the
monochrome drawing usually suffice for this purpose. The ink shad-
ing is divisible roughly into dark, middle, and light; and three cor-
responding divisions of slightly lighter
color laid over the drawing will pro-
duce a graded opalescent tone, or
scumble.

If the ink drawing is executed in
washes, this graded scumble will be
continuous; for the darker ground
runs evenly beneath it. If, however,

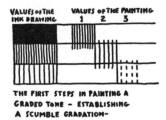

the graded values of the drawing have been suggested by lines or
hatchings, averaging the effect of black lines and white gesso, the ef-
fect of the painting will alternate correspondingly between dark

lines of opalescence and less dark, transparent spaces of color between them. The value contrast will, of course, be much less than in the drawing. The opalescent effect of the painted tone will in any case be directly proportionate to

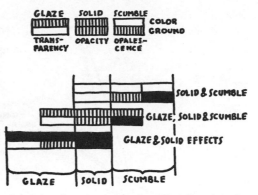

the depth of value secured in the drawing, whether the drawing be done in wash or in line. Each method has its uses and its adherents.

The order of painting

Turning now to the actual painting of the panel, consider where you shall begin. If there is any flesh painting, it is best done last; for it is easier to key a comparatively small area of flesh to a large area of drapery and background than the other way about. With this exception, however, it is advisable to begin with the most distant planes and to work forward. The advantage of this order of work is that the edge of a forward plane can thus be painted over anything that lies behind it. If two areas are simply butted, both painted up to a line, the edge between them can never be made quite so clean and clear as when one overlaps the other slightly. When you are bringing a tone up to an outline, draw the edge with the heel of the brush, not with the point. The heel gives a firmer, truer line; for it can be controlled better than the point.

A hypothetical case

As nothing can be more distant than a sky, we may begin the discussion of painting procedure with a hypothetical sky, and assume, for the sake of argument, that what is wanted is an even gradation from a dark blue zenith to a white horizon. This will have been indicated in the ink drawing on the panel by a gradation in line or wash from the black of the ink to the white of the

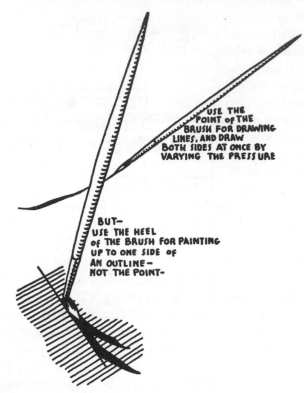

USE THE
POINT of THE
BRUSH FOR DRAWING
LINES, AND DRAW
BOTH SIDES AT ONCE BY
VARYING THE PRESSURE

BUT—
USE THE HEEL
of THE BRUSH FOR PAINTING
UP TO ONE SIDE of
AN OUTLINE—
NOT THE POINT—

gesso. We shall want a corresponding gradation in transparency, from almost transparent dark blue at the top to an almost opaque white at the bottom.

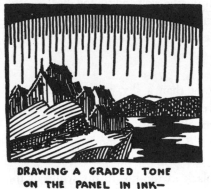

DRAWING A GRADED TONE
ON THE PANEL IN INK—

Mixing values

Let us choose cobalt blue as our basic pigment. If necessary, we may make up a special mixture, turning it a little green with oxide of chromium, or a little violet, say with Indian red; but in this case, we must put aside

some of the mixed color as a separate pigment, and keep it until the painting is finished; for it may be needed again. We will then take three color cups, and into the first put a fairly large amount of the cobalt blue (pure or compounded), and into the third, a very small amount. We will add a small amount of white to the first cup, and a large amount to the third. When each of these mixtures is stirred, we shall have one cup containing a dark blue, and one containing a light blue. Let us put some of each of these into the middle color cup, and mix them together to produce an intermediate blue.

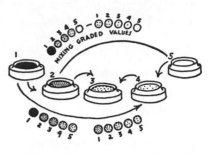

Each cup should have its own brush, and each mixture must be tempered with egg for use.

Applying the tones

Now our darkest mixture of blue is not so dark as the ink modeling at the top of the sky; but it is darker than the drawing farther down. If, therefore, we start painting at the top of the panel, and work gradually down with this dark blue, passing from the darker part of the under drawing to the lighter, we shall see the change in effect discussed above. Where the color lies upon a ground darker than itself, it appears opalescent; where it matches the value of the ground, it begins to look opaque; and if we went on to the still lighter part of the drawing, it would look transparent. Stopping gradually where the blue matches the value of the ground, let us apply two or three coats of it, thinly and evenly, just enough to make the drawing underneath disappear as a drawing, and tell only as modeling in the blue.

We then take the intermediate mixture of blue, and begin again in the same way from the lower edge of the dark blue portion, painting thinly over the dark blue edge and the whole middle part of the ink modeling of the sky, and losing the middle blue in the lightest part of the ink drawing, down toward the horizon. The

drawing again tells just as modeling in the blue. And then we take the lightest of our three mixtures, and in the same way paint thinly over the lower edge of the middle blue, over the last of the lightest part of the ink drawing, and all the way down to the horizon. Then finally we temper some pure white, and paint thinly over the bottom part of this lightest blue until we have made the necessary transition to white at the horizon.

Glazing over the scumble

Now we may take a little pure blue, adding perhaps still a trace of white, but making it in any case darker than the darkest of the original three mixtures; and, thinning it out with a great deal of water and using the brush almost dry, we may play it over the top part of the sky very thinly, gradually making the tone as deep and transparent as we wish. And in the same way, the other tones may be played thinly over the next tones lighter, each acting as a very delicate glaze. We could easily give the whole sky a uniformly transparent appearance, or, of course, equally easily, a uniform opacity; but what we want is a graded transparency, from the opaque or semi-opaque white of the horizon to the almost transparent dark blue of the zenith. This we can easily secure by breaking a little transparent color over the opalescent tone that we have already established, grading it as we please by simple manipulation of the brush. "Transparent" simply means darker over lighter.

If the modeling of the sky is not perfect, the tones may be applied again, in the same order, and the form corrected. When all this has been done skilfully, we shall have a very even gradation from dark blue to white, with no suggestion of bands of separate colors. And the blue will have a luminosity, appropriate to a sky, which would be hard to secure in a water medium by any other means. We shall have accomplished this by taking advantage of the semi-transparency of the coats of tempera color.

Tempera vs. gouache and water color

This lengthy account of a simple piece of painting may well strike the reader as tedious; but the principle that it is intended to illus-

trate is fundamental to an understanding of the essential character of tempera technique. Tempera painting is often confused with gouache, on the one hand, and with water color on the other. The basic differences among these media boil down to questions of transparency. Tempera stands midway between transparent water color and opaque gouache, and possesses a flexibility, in consequence, which neither of the others shares. Tempera is not to be thought of as a material: it is a discipline. It is possible to temper pigments with much yolk of egg and little or no white, and to paint water color with them; or, with much white and little egg, to use the same materials for gouache. But tempera painting proper means capitalizing this special character of translucency that sufficient tempering gives to thin coats of pigments in themselves opaque. It means distinguishing the effects of opacity, produced by repeated coats of a single tone, opalescence, produced by painting a lighter tone over a darker, and transparency, produced by painting a darker tone over a lighter.

This wide range of effects is easily, almost automatically controlled, and it gives the tempera painter an instrument of great power and adaptability. If he makes use of its special properties, it will reward the inconvenience to which it puts him. There is no sense in turning a studio upside down to gesso panels, grind colors, and then paint gouache. Good drawing paper stretched on a frame, or a good illustrators' board, and any of the excellent ready-made gouache preparations, will give just as good results. It is only to take advantage of the powers and beauties peculiar to tempera that the painter is justified in giving himself the trouble of practicing it. If he will be content with a graded wash of blue, it is folly for him to look farther than water color; if he will be content to blend his graded blue from dark to light out of opaque mixtures by scrubbing with a brush, his needs can be satisfied by good commercial gouache. But if he wants to control the painting to perfection, to shape the sky as he paints it, to give it some special quality of luminosity, to establish some deliberate relation between it and the rest of his painting, it may be worth his while to grind colors and break eggs instead of buying tubes and bottles in a shop.

Nothing is a harsher test of a tempera painter's skill in his medium than this very problem that we have been discussing, a graded blue. Even competent painters often make their broad, light gradations chalky or streaky, for want of thoughtful handling. The secret is to preserve the opalescent half tone; for it can be turned toward transparent or opaque, and shaped and modeled as easily and subtly as clay under a sculptor's thumb.

Painting drapery and other objects

Exactly the same principle applies to the painting of solid forms, such as drapery. The values are established on the white panel with ink shadings, and three main values of color are mixed, corresponding to light, half tone, and shadow, or half tone, reflected light, and shadow. For the simplest manipulation, these mixtures may be made, as before, simply a color with a little white, the same with more white, and finally with more white still. There should ordinarily be some white even in the darkest of these values, partly to insure its opalescence over the darks of the drawing and partly so

that the pure color will be in reserve for final glazing. The darkest value is laid on once or twice, thinly, over the darkest parts of the drawing; then the middle value is laid in; then the lightest. They are blended nicely at their junction lines, the darker being carried over the lighter at the edge, or the lighter over the darker, according to the form. Where these tones are laid, and in what relation to each other, depends, of course, upon the system of light and shade which is being used.

Development of the forms

In this stage, the form is incompletely rendered. The half tones are finished, but the lights are not light enough, the shadows are not dark enough. The drawing underneath gives some shape to the reflected lights and the shadows; but they are pearly, translucent,

unconvincing. To give the shadows the necessary depth and transparency, it is only necessary to make a value slightly darker than the darkest (perhaps pure color, without any white), and break it thinly, well diluted, and with the brush almost dry, over the opalescent tone which resulted from the first laying in. The color deepens and becomes transparent almost as if by magic. The transition to the pearly half tone may easily be kept; and the form will be found exquisitely plastic, shaping up under the brush with the utmost ease and accuracy. Any degree of precision is possible at this point. The painter may shape the form as delicately or as boldly as he wishes; for it will do

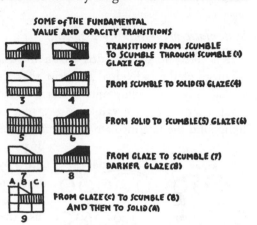

SOME of THE FUNDAMENTAL
VALUE AND OPACITY TRANSITIONS

TRANSITIONS FROM SCUMBLE
TO SCUMBLE THROUGH SCUMBLE (1)
GLAZE (2)

FROM SCUMBLE TO SOLID (3) GLAZE (4)

FROM SOLID TO SCUMBLE (5) GLAZE (6)

FROM GLAZE TO SCUMBLE (7)
DARKER GLAZE (8)

FROM GLAZE (C) TO SCUMBLE (B)
AND THEN TO SOLID (A)

exactly what he makes it. It is here that the individual brush strokes begin to tell; and from this point on the description of the forms and the stylishness of the handling depend very largely on the understanding and dexterity with which the brush is handled.[1]

The modeling is now complete from half tone to shadow, and it remains only to build up the lights. This is readily done with as many lighter values as the case requires. Each lighter mixture is made to produce as much effect as it will before the next is taken. The final highest lights may be touched in with quite thick paint. In general, the lights should be modeled *up,* with rising values; for so consistent is the tendency of tempera to exhibit its half-transparent nature that even in the lightest values a thin painting of a tone over a lighter tone will give a glaze effect. In practice, one often models the lights up, and down, and then up again, to get them strong and solid. At the very end, you may accent with extremes of

[1] See "Form Drawing" in the Appendix, p. 132, below.

light and dark. If a painting is pitched to the key in which tempera is most effective, there will be some part, large or small, somewhere in it, painted with pure white. It may or may not go down to pure black at the other end of the value scale; but it is almost axiomatic that the lightest stroke in the painting should be made with pure white paint.

Systematic value mixing essential

It is likely to be regarded as an intrusion upon the sacrosanct privilege of the individual to insist that there are right ways and wrong ways of mixing intermediate values. Nevertheless, if you want a series of three values, 1–3–5, mix 1 light, and 5 dark, and compound the intermediate 3 by mixing some of 1 with some of 5.

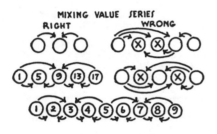

MIXING VALUE SERIES
RIGHT WRONG

If you want a series of five, create 2 by mixing some of 1 with some of 3, and 4 by mixing some of 3 with some of 5; and use the same principle if you want a still longer series. This is not an arbitrary whim: there is a very practical reason for doing it this way, and not, as painters are used to doing, by eye. If the lightest value, 1, is white, and the darkest, 5, is black, the reason does not appear; but if 1 is white and 5 is pale yellow, it will immediately be found, on experiment, that a graded series cannot be mixed by eye alone. Even in less extreme cases than this, it will be found difficult or impossible to distinguish between close adjacent values as they stand in the color cups. But mixtures which look identical in the color cups tell as very different when they are painted out. It is possible, and sometimes extremely useful, in tempera to model very fully and completely within a very narrow value range. It is quite possible to model with a series of three or five or seven value steps between white and pale yellow or pale gray, and to have each value count in the modeling. Some of the most precious effects of tempera painting depend on this power of compressing

the value scale without reducing the completeness of the rendering. The smoothness of the surface and the clarity of the painting make every variation of tone effective; and it is quite practicable in tempera to model fully between value limits which in other media would preclude the use of any modeling at all. It is, however, necessary to mix the members of the value series systematically, and to keep the cups in order during the painting process.

Variations of color system

Mixtures of a single color with white have been described as the simplest basis of manipulation, and so they are. (The single color may, of course, be a simple pigment or a mixture of pigments.) One is often content to model an area from vermilion in the shadows to white in the lights, or from opaque oxide of chromium to white. Modeling of this sort is perfectly descriptive, though arbitrary. Sometimes, however, one wants an entirely different sort of effect. It is desirable from the point of view of mechanical handling and also of orderliness in the painting to achieve one's effects by some systematic means; and when the basic system, pure color to white, will not serve, to substitute some other equally systematic method. It is inconvenient in practice to try to mix each value by eye to a separate color, and the result of an attempt to do so is not likely to be happy.

Two modifications of the pure-color-to-white system are adequate to many purposes. First, the substitution of some other color for white. Instead of modeling vermilion up to white, it may be modeled up to yellow, or a mixture of white and yellow, for example; and green in the same way. Or green may be modeled up to light blue, or to a lighter green of different composition. This system requires only the substitution of the new light for white in the other method, but it produces a totally different series of colors, and introduces a marked color change accompanying each change of value. The second modification is to put the pure color in the middle value instead of in the dark. Vermilion in the reflected lights, for example, may be mixed with white in the half tones and modeled

up to white in the lights; while the shadows are made with madder red or alizarine crimson. Oxide of chromium may be modeled up to cadmium yellow in the half tones and lights, and given viridian or cobalt blue for its shadow. Cobalt blue may be modeled up to white (or pink, or yellow, or anything you please), and down to purple, or black, or dark green. The intermediate values, if any are required, between the pure color in the middle and the other colors at the top and bottom of the scale, are made as before by mixing.

These simple, systematic bases for color and value series permit a wide variety of color effects without complicating the manipulation of the medium. Others may readily be devised. Adopting a systematic modeling scheme imposes no greater hardship on a painter than the conventional divisions of the musical scale impose upon the musician. If a composer cannot make shift to write music within the limits of the keyboard, he need not look for a performance of his works on the piano. If a painter feels the need of more liberty in the matter of color changes than is compatible with any simple system of pigment mixing, he will not find satisfaction in tempera painting. There are many worthy points of view about painting, and tempera is only one of many methods. Good tempera painting depends on a painter's willingness to accept certain limitations in return for certain powers. Other media offer other powers—and impose other limitations.

Treatment of surface effects

It is perhaps hardly necessary to say that surface effects, such as the pattern in a drapery, should be painted in after the main forms are modeled; but the same principle can often be extended widely. Paint the neck and add the necklace; paint the waist and add the belt; paint the head and then the veil which hides it, the sky, and then the branch across it, the floor, and then the tiles, the bowl, and then the pattern on it. Even such an extreme subject as a Scotch plaid will yield to treatment of this sort! Necessary accidents of color, as in reflections, may be inserted at the end. The painter of naturalistic effects will not wish to work this way; but it is a good way, all the same.

Painting flesh

I have and treasure some little nineteenth-century booklets on painting which describe exactly how to paint landscapes and portraits. They tell me just what colors to mix together for every purpose; their authors almost hold my brush. They could hardly be worse than they are, or more dogmatic. Yet I feel that I may seem to be running into the same sins. I have described the painting of a sky, almost stroke by stroke, and am about to describe the painting of a head. Let it be understood that these notes are not meant as formulas but as illustrations. I have no special fondness for paintings of skies graded from dark blue to white; I do not want them painted to my order. In my little 1860 booklets which tell how to paint foliage and hair and satin dresses and running water and sunset effects there may be found some sage and useful counsel on the handling of oil paint. Perhaps there is no other way to teach the nature of a medium than in terms of practice, at the risk of seeming to expound a dogma. I am going to describe the painting of a head in the Giottesque manner; but I do not want to see a modern painter turn Giottesque. There is something to be learned from this method of Cennino's, in painting flesh, something that a modern painter may absorb and turn to good account; but it calls for metamorphosis.

If you have modeled a head carefully in ink on the white surface of the gesso, and you pass over it, as Cennino directs, two coats of terre-verte and white, well tempered, you will have the effect of an underpainting in green and greenish gray. Terre-verte is a particularly transparent, fat color. Some samples are quite warm, almost yellow, and others cold and blue. Upon the exact shade of the terre-verte depends the exact color of the pearly, opalescent, greenish gray which appears in this underpainting wherever the paint lies over the darker drawing; but whatever the quality of the sample, it will yield some sort of pearly tone all over the half tone and shadow areas. Curiously enough, this tone does not depend on the color underneath: that may be ink or paint, brown, or black, or red, if you please (though there is no need to use anything but India ink). The effect of the green over it will be almost exactly the same in any

case; for this opalescence depends only on the darkness of the color underneath.

If you mix a little brown, say yellow ocher with a touch of black and earth red and a little white, temper it, and thin it out well with water, you can shade and model this pearly half tone down and around into shadow, making it warmer, darker, and more transparent at the same time. The play of dark, transparent warm over lighter, opalescent cool will give you perfect control over the modeling of the shadow both in form and color, and in transparency as well. You will want to take pains not to lose the pearly, silvery quality of the half tone by carrying the brown shading (which Cennino calls "verdaccio") too far. Where you place the shading depends, of course, on how you are handling the light and shade; but whatever your system in that may be, you will have some place for every degree from the untouched scumble of green to the full strength of your verdaccio.

Next you may want to mix a color for the redness of the cheeks, and lay it in place, carrying it thinly as far into the shadow as you wish, and establishing it strongly in the lights. Then mix a general flesh tone, or two, or three, if the case seems to you to require it, and work the lights up to the edge of the half tones or shadows. Mix as many lighter flesh tones as you need, and build up the lights with them, reinforcing variations of local color in the lips and cheeks and chin and forehead as you go. At the end, you may have some crisping up to do with verdaccio, or other dark color, and light colors, or pure white. You will follow the universal principle of developing the form gradually, keeping it open and plastic, under your control, until you are ready to make it definite and fixed by a few decisive strokes.

Painting hair

In painting flesh, do not try to stop short at the hair. Paint the flesh well over the outline of the hair, and then paint the hair back in again. The two coats of terre-verte may as well be laid over the hair as not. When the head is painted, restore the drawing of the

hair with any dark color you please, verdaccio or black, it makes no difference what, and lay one or two coats of whatever local color you wish over it. The dark drawing will show through a little, and cause the ocher or red or brown or gray of the hair to exhibit the indispensable opalescent half tone upon which you work your shadows and reflected lights. Paint in the direct lights opaquely with suitable color; and if you like, finish with some drawing strokes of fairly thick paint.

Variations of method

This is not to be regarded as a formula, but as a system subject to much variation. You may not wish to underpaint with terre-verte. You may not like the half tone that green gives. If it is too green for your taste, use brown or yellow or red or blue or anything you please. (Blue is a superb preparation for the painting of black flesh.) If it is not green enough to suit you, use viridian! The whole point is to create some relatively cool half tone, midway between transparent and opaque, and this can be done with any color in your palette. You are at liberty, within the system, to make your colors anything you please, to apply them delicately or boldly, in an abstract scheme of modeling or in the most scientific order of light and shade. The adoption of the basic system simply gives you control over warm and cool and transparent and opaque with a minimum of labor and a maximum of flexibility.

This is the whole purpose of the manipulations described in this chapter: to achieve control of the effects of painting through the systematic use of the materials. There are other systems which may be used. You may lay in all the areas of the painting in flat tones of middle value, and model them up and down with lighter and darker values. That is a good method, especially for small-sized works. In place of the monochrome ink drawing on the panel, you may lay in your shadows first with dark local color, scumble them over with a lighter value, and restore the transparency with a glaze *ad lib.;* and that is not a bad method at all. Every painter will find his own level, work out his own applications, or reject the medium

entirely. It is not suitable to everyone, or to all purposes. When it is suitable, however, it offers an economical means of producing work of exceptional power and beauty.

Final embellishments

It remains only to speak of mordant gilding, and the processes of painting and embellishing most useful to the panel painter will all have been discussed. We have seen how broad grounds of metal may be laid and burnished; how patterns of gold and color may be formed by painting over the burnished gold, scraping away the color in a pattern, and graining the exposed gold. We have considered the use of powdered gold as a pigment, for modeling on other colors. Now let us look at a further use of gold, gold laid in the form of leaf in a determinate pattern on the top of color. This type of gilding, called "mordant" gilding because it is *mordanted* in place, differs strongly from burnished gold and from shell gold in effect. It may be used for large areas, especially as a ground for glazings of color, usually in oil; but its characteristic application is in rather fine lines or dots or small shapes on a colored ground. The principle is to work the design out in a sticky material, the mordant, and then to cover it with gold leaf, brushing away the gold leaf from the parts not covered by the mordant. This method gives the effect of an incrustation of gold upon the painted surface.

Water mordants

There are two types of mordant for this purpose, oil mordants and water mordants. Oil mordants are more durable, and on the whole more satisfactory than water mordants; but they are more troublesome to prepare in the first instance, and a little more exacting in use. A very good water mordant may be made by pounding cloves of garlic in a mortar and squeezing out the juice, through a linen cloth, adding a little powdered gum ammoniac (which may be left in it overnight to soften and dissolve), and grinding to a fairly stiff paste with white lead and a little bole. The gum ammoniac is not absolutely necessary, but is an improvement.

Oil mordants

No commercial gold size is altogether satisfactory as a mordant for use on tempera paint. Japan gold size is too thin when used alone. It tends to run and spread, making untidy lines. It dries too quickly and unevenly on the tempera surface. The fat-oil gold sizes are better, but they generally dry too slowly for convenience (often requiring a week or more to develop the right tack), and contain too little pigment to make a good line. Pigments ground in Japan, such as chrome yellow, have body enough, but tend like Japan alone to paint out too thinly, or else to make a crude stroke. Chrome yellow in Japan mixed with a good fat-oil size and a drop or two of strong copal varnish gives a mixture which will flow out of a brush in a fine line and settle to a smooth enamel surface without spreading. One has to experiment with the mixtures until he is satisfied. Of the commercial preparations, those sold as "Quick oil gold size" are probably the most suitable. For very fine and delicate work, it is desirable to have a mordant which will "thread" from the brush, and yet be sticky enough to hold well on the painted surface. This is more difficult to achieve. It can be managed, however, by boiling such a mixture of pigment, fat-oil, varnish, and Japan as has been described, cooling it, and boiling it again repeatedly until it is almost rubbery in consistency.

Another way is to boil a small amount of linseed oil (out-of-doors, or under a fume hood, for it makes a very bad smell), until it is about as thick as strained honey; grind it, as Cennino directs, with some white lead and, if you like, a little verdigris; add a little powdered sandarac resin; and boil the mixture together for a few minutes. The consistency may be varied by adding more oil or more resin, until it suits you. It is quite impossible to give any definite

rule for a mixture of this sort made in small quantity. One need hardly make up a mordant more than once in a lifetime; for an ounce or two, tightly stoppered, will last indefinitely, and a very little goes a very long way.

Applying the mordant

Whichever type of mordant one uses, the application is much the same. A brush is chosen in proportion with the scale of the ornament to be applied, and the mordant very carefully and neatly laid on. It is a good plan to brush a little glair thinly over the section of the painting which is to receive oil mordant gilding, and let the glair dry before the mordant is applied. This thin film of glair will keep the gold from sticking to the surface of the paint. With a water mordant this is not a sufficient safeguard, and if the surface of the painting seems at all sticky or greasy, it should be dusted lightly with powdered French chalk before the mordant is applied. If the mordant tends to soak into the surface, it will dry too quickly and unevenly, and the painting should be sized locally with one or two thin coats of one-to-sixteen gelatine solution, or with a thin solution of gum benzoin or shellac in alcohol, to render it less absorbent.

Gilding

The water mordants dry promptly, and may be gilded soon after application. Indeed, they often dry so quickly that it is necessary to breathe lightly on them to restore the stickiness. This breathing should not be carried further than necessary, as it may make the mordant too wet. Oil mordants, on the other hand, require some time to dry. Japan alone may be too dry in half an hour, and a fat-oil gold size may be too soft at the end of a week. It is impossible to predict the amount of time required for drawing; but for a given mordant it will not vary much, and when you know your material you can tell whether to plan to gild in eight hours, twenty-four, forty-eight, or whatever it may be. It is most convenient to have a mordant dry in twelve to eighteen hours; for then what you lay one day will be just ready to be gilded the next morning. The gold should be laid as soon as the mordant is tacky. You should be able

to run your finger tip lightly along a line of the mordant without smearing it, yet it should be tacky in the thinnest parts when you touch it with slight pressure. Cut the gold on the cushion as required. Lay it along the mordant with the tip, overlapping the leaves always in the same direction. When all the mordant ornament is covered with gold, press the gold down with a camel's hair mop and then with a bit of cotton, lightly at first, then harder. Apply more gold if you find it necessary. Then take the mop or a fair-sized sable brush, and delicately skew away the loose gold, and work the skewings back and forth over the mordant gilding so that they will stick to any tiny places which have not taken the gold. It is often wise to gild while the mordant is a little fresh, and then to leave it for a day or two to dry and harden before dusting off the excess gold. To lay the gold on the mordant, cut the leaf as required, and lift it by the edge, as shown in the drawing on page 126, below.

VARNISHING AND FRAMING

Permanence of tempera painting

GIVEN good workmanship and good materials, and a reasonably healthy environment, a tempera painting may be expected to keep its essential character unchanged for centuries. It is more permanent than oil painting; far more permanent than any painting which can be done with the conventional materials of modern oil painting. It will not survive protracted extreme dampness; it is not fireproof; it can be injured mechanically; but it is extremely durable, and any troubles which may beset it in old age are usually readily repaired. Paintings in tempera which have knocked about for six or seven hundred years are far more nearly in pristine condition than many paintings in oil executed since the Great War. Egg tempera provides perhaps the most durable, unchanging painted surface that a medium useful for picture painting can produce.

Importance of varnish

For protection against surface dirt, atmospheric gases, and moisture, however, the painting should be varnished. It is neither necessary nor desirable to varnish any burnished gilding that the composition may contain, but the painting proper should have the protection of a coating of hard resin. The best resin for this purpose is, in my opinion, mastic. A mastic varnish affords good protection to the surface for twenty or thirty years, and at the end of that time may easily be removed and replaced without the slightest injury to the painting. It requires care in application to produce a good result, and the following method should be followed.

Cleaning the surface

First, allow the painting to stand for at least a year before you

varnish it. Then wipe the surface carefully with a silk cloth, to remove any dust which may have collected upon it. If there is any oil mordant gilding, apply two coats of weak gelatine solution locally, with a small brush, to protect it from solvents which may be used later on in removing the varnish. Wipe the surface of the painting lightly with absorbent cotton damped with fresh pure turpentine, to remove any grease or soot.

Precautions against dust and damp

The room used for varnishing should be given up to it entirely and not used for any other purpose while the varnishing operations are going on. Every precaution should be taken against dust and draughts. The floor should be swept up with oiled sawdust, and the surface of the bench or table upon which the picture lies should be wiped with an oily cloth. The temperature of the room should be, if possible, as high as 70°, and the picture, the varnish, the turpentine, and the varnish bowl and brush should all be left there together for

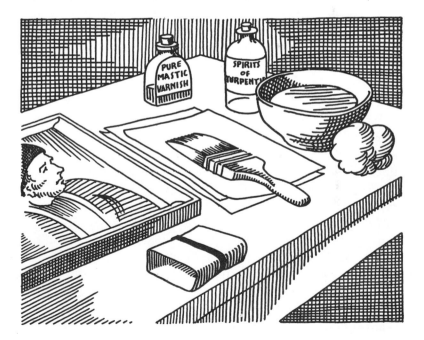

a day or two before varnishing. The varnish brush should be washed thoroughly with pure turpentine, rubbed out as dry as possible on a piece of brown paper (not newspaper), wrapped in brown paper, and fastened with a rubber band.

Choice and care of the varnish brush

The varnish brush should have long bristles, and be large in proportion to the work. If you have to avoid a background of burnished gold, you may find it convenient to have a second brush to begin with, say one inch wide; but in general no varnish brush should be narrower than three inches. If you are varnishing a whole panel, brush the varnish on first from side to side as quickly as possible, and then strake it out with firm, even strokes from top to bottom. Do not touch back on the varnish, no matter what happens. If you have missed a spot, or let a drop fall on the finished part, or made any mistake of that sort, wash the varnish off with turpentine, let it dry overnight, and start again. Never wash a varnish brush with soap and water, and never let it dry. Clean the varnish out with turpentine, or petroleum, and if you use it infrequently, so that it might dry out, oil it with raw linseed oil. Wrapped tightly in brown paper, it will stay soft for a long time, and need only be washed out thoroughly in turpentine to prepare it for use again. Varnish brushes improve with age when treated in this way, and an old brush is much easier to do a smooth job of varnishing with than a new one.

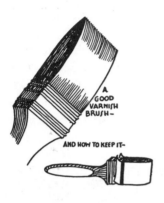

A GOOD VARNISH BRUSH—

AND HOW TO KEEP IT—

Applying the varnish

After a day or two, the picture and the varnish and implements will have come to an equilibrium in temperature, and any dust in the room will have had a chance to settle. Enter the room quietly, so as not to raise any dust in walking. Wipe the picture again with

a bit of cotton damped with turpentine. With the same damp cotton, wipe out the varnish bowl, and pour into it a generous amount of picture mastic varnish, a solution of gum mastic in turpentine. Add to this an equal quantity of pure fresh turpentine, and mix the varnish and the turpentine very thoroughly with the varnish brush. Thorough mixing is very important: it should be continued for several minutes. If the mixture seems in the slightest degree thick or sticky, add a good deal more turpentine, and continue the mixing. Then brush it onto the panel as quickly, as thinly, and as evenly as possible. Throw away your varnish mixture, wash out the bowl and the brush with three or four small lots of turpentine, rub the brush dry on clean brown paper, and wrap it up again. Then leave the room quietly. After twenty-four, or better forty-eight, hours, repeat the process; and if when the second coat of varnish is dry it is not perfectly smooth and shiny, apply another coat in the same way. Do not try to varnish in one coat. Thin coats brushed out smoothly are very much better than a thick coat.

Flatting the surface

The surface of a newly varnished picture is brilliantly shiny. This shine grows less of itself in the course of a few months; but if you want to make the surface matte, you will need to wax it. The use of wax over a thin mastic varnish adds to the protective power of the varnish, and preserves the painting perfectly. The best way to apply the wax is in solution. Dissolve some pure, genuine beeswax, unbleached, in refined benzole, by putting them together in a bottle and standing the bottle in hot water. While the mixture is still warm, paint some of it thinly over the varnished painting, using a broad soft brush. As it cools and dries it forms a hard matte film over the varnish which may be left as it is or given a slight luster by polishing with a soft cloth. Varnish can be flatted by rubbing down with tripoli and oil; and for small paintings that is often more satisfactory than covering it with wax. But when wax can be used, it is an advantage; for it can be washed off at any time, and the surface of the painting cleaned in the process. Never use the so-called "matte varnishes." They do not provide adequate protection.

Function of a frame

Panels which are not self framing or designed to fit into some definite architectural setting generally require frames to show them off. In designing a frame, the effort should be to keep the picture

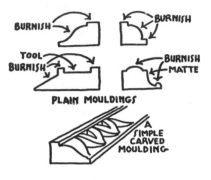

PLAIN MOULDINGS

A SIMPLE CARVED MOULDING

from running into the wall, and the wall from running into the picture. A frame should try to present a maximum of contrast with the picture and the wall on which it hangs, in scale and color and texture. As pictures and walls usually contrast rather strongly with each other in these respects, the frame is apt to be as harmonious with the one as it is contrasting with the other; so this principle is often not recognized. A burnished gold frame may usually be counted on to contrast with both picture and wall; and is therefore a solution of wide applicability. But if a painting contains burnished gold, it may be worth while to use matte gold in the frame, or not use gold at all. The long established convention of the gilded frame has certainly begun to lose its force; but as it still possesses some vitality, we may consider its technical side. Burnished gilding has been discussed above; let us examine the possibilities of matte gilding.

Matte gilding

There are two ways of getting matte effects in gilding, one water gilding, the other oil gilding. The former is far more durable and beautiful; the latter, less than half as troublesome and expensive. They are both useful for frame gilding, and that is the only use most painters will make of either. This is not the place to go into the refinements of frame gilding, such as the combination of burnished water gilding with oil gold, but the essential principles of the art may be outlined, as far as they differ from the practice of burnished gilding already described.

Water matte

For matte gilding with water, the frame is prepared with bole and size as if for burnish gilding, and gilded once in the same way. Any areas which are to be burnished may be finished at this stage. Parts which are wanted matte should be painted over thinly with a one-to-twenty-five solution of gelatine mixed with about a third of alcohol. This mixture is called a "clear coat." In the hollows, occasionally, and for a cheap effect, all over, the first gilding may be left in this condition. For a really fine matte, however, the whole surface should be regilded over the clear coat. To preserve the finished gilding, which is rather delicate, a thin coat of clear lacquer should be passed over it.

Oil matte

The practice of oil gilding is simple, and well adapted to the production of satisfactory frames of large size with gold or other metal leaf. The frame is drawn up in the gesso as usual, and finished with as much care as the gilder wishes. It is then given several coats of size or perhaps more conveniently several coats of very thin shellac, enormously diluted with alcohol. It is then coated thinly and evenly with an oil gold size. Excellent commercial preparations for this purpose are available, and are usually so adjusted that they may be gilded at the end of twelve hours or at any time within eighteen hours, or in some such convenient way.

For oil gilding, it is convenient to have long leaves of gold, a size larger than is usually used for water gilding. "Transfer gold" may be used for oil gilding—and for nothing else—but it costs more, is usually more extravagant to use, and possesses no advantages for the indoor worker, provided he has learned to handle leaf on the cushion. It is important in oil gilding that the overlaps of the leaves should all lie in one direction, so that they may be pressed down in the skewing, and not ruffled up. In order to be able to gild the hollows without having the gold catch on the tops, it is usual to gild the tops first, all around the frame, working always in one direction. The gold may then be allowed to slide over the parts already

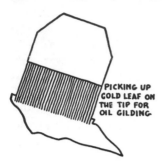

laid and down into the deepest hollows. In gilding curved surfaces, the gold is not picked up flat on the tip, but simply lifted by having an eighth of an inch or so at the edge of the leaf attached to the hairs of the tip.

Skewing down

When the whole frame has been laid in leaf, a camel's or badger's hair brush is drawn lightly over it in the same direction as the gilding, to press the leaf down upon the size. With a camel's hair mop or duster, the loose gold is then lightly swept along the moldings, and skewed over the tiny places which may have been left bare. Do not try to cover a spot of any size with skewings, but lay a bit of leaf on it. Break up the skewings as slowly as possible; for the fine dust does not cover as well as large bits. Continue the skewing for a long time. The continued light pressure of the brush is essential to a good effect. The gold is pressed into perfect contact with the size, the skewings attach themselves to any tiny open spots, and the whitish look of the freshly gilded moldings gives way to an agreeable polish. The skewings should finally be collected (a large clean paper under the frame makes this easy), and saved; for in the course of time one accumulates enough waste gold in this way to be well worth sending back to the gold beaters for an allowance against the cost of new leaf.

Frame edges

The outside flat surface of a thick frame is usually better painted than gilded. For this purpose, mix powder color (usually ocher, or ocher and umber) with some one-to-sixteen gelatine solution, and apply two or three coats, cold. This dull color often looks and wears better than gilding on the outside of a frame; and it can easily be renewed if it gets worn or dirty.

Antiquing

Particularly on oil-gilded frames, it is often desirable to do some toning or "antiquing." This may range from a slight modification of the color, to bring the frame into harmony with the painting, to the most dire imitations of the disasters of centuries of wear. In either case, leaving out of account methods of deliberate fraud, the system is the same. Color is applied with size. Those who care to do so may rub a little of the gold off the tops and corners of a water gilded frame, to suggest wear, and to let the red bole show through. A damp cloth is good for this artistic operation; or a fine abrasive, such as emery powder, may be used. Oil gilding should be allowed some time to dry and harden before any further treatment is applied, and should then be given a clear coat of one-to-sixteen size, repeated if it seems necessary, to protect it.

The water gilded surface, or the oil gilded surface covered with a protective coating of size, should next be given two or more coats of very thin shellac. Some color may be added to the shellac if desired, to alter or deepen the color of the gold. Alcoholic solutions of gamboge and dragonsblood are usually used for this purpose, but Bismarck brown and other dyes may be employed. When the shellac is dry, colors are mixed with size exactly as for tinted papers, and painted over the surface with a bristle brush. The brush strokes may be allowed to show, or they may be stippled out with a badger blender. Repeated coats may be applied, and all manner of trickery introduced. The tops of the gilding may be wiped off between coats; colors may be alternated; dry powdered colors may be rubbed on the dry coats of size paint to simulate dust or to change the tone a little. The final product may be given a light coat of wax to preserve it, or left as it is.

Nothing in the way of fancy treatment, however, can produce anything like the richness and beauty of good gilding naturally aged. Good water gilding improves rapidly in color and surface. It may seem a little garish just at first, but two or three years will bring it down to a tone which no faking can equal. Those who admire a decrepit quality in frames will find that raw umber, chalk, and ultramarine blue will give appearances of the most hoary an-

tiquity. Those who admire richness will rely upon dyes in the shellac, and glazings of red bole, burnt umber, Vandyck brown, and burnt and raw sienna. Those who are struck by the harmony of silver frames with blue or other cool color schemes will find that the "oxidized-silver" effect can be produced on a ground of burnished silver by the use of gilders' gray clay and lampblack.

Other frame materials

Having suggested the trickeries of these arts, I cannot refrain from saying that I see more virtue in a painted frame than in a metal frame sodden with antiquing. I will not speak of the metal bronzes; for they are certainly not fit for serious use. But paint, white or colored, frankly and decoratively applied, seems to be the logical solution of the frame problem for those who cannot bear the sight of uncontaminated metal. If you want to paint a frame, mix your colors with size, and apply them over the gessoed molding. Wax them a little with beeswax made into a paste with turpentine, and polish them or not, as you please. If you want a metal frame, use gold or palladium leaf. Aluminium has its uses; but I have never seen it look well on a frame. If you want other metals—copper, silver, or pewter—have the frame covered with foil or thin sheet metal, and lacquer it if you want to keep it from tarnishing. Then if it does tarnish, it can be cleaned and made like new.

For white frames, the gessoed wood is sometimes left untreated, or merely waxed; but a more satisfactory and durable white finish may be obtained by painting the gesso with titanium white mixed with a one-to-twenty size solution. Dark colors scumbled over with lighter colors or white are sometimes highly successful. To protect these finishes, it is wise to apply a little thin shellac, and then beeswax.

ARTIFICIAL EMULSION PAINTING

Unlimited possibilities

I HAVE referred briefly here and there to other sorts of tempera and other kinds of handling. Some of the most useful and agreeable of these techniques depend upon the use of artificial emulsions. Egg yolk is a natural emulsion, a mixture of watery and oily parts. Artificial emulsions may be made in innumerable combinations, many of which have strikingly individual working characters as painting media. Some are good, some bad, technically considered. Some are strong and permanent; others are not. Some contain soaps and other objectionable ingredients; others are stably compounded out of innocuous and mutually compatible materials. Only the most cursory reference to these media can be given here.

A basic formula

Certain substances act as emulsifying media. Oily materials can be added to them, and then watery materials, and the oil and water will not separate, but remain for some time in intimate mixture. The most important bases for artificial emulsions are egg yolk, casein solutions, and glue. These form genuine emulsions with oils and varnishes, which may be used for serious painting. So-called emulsions made with gum water are to be avoided. An emulsion may be made from pure egg yolk and oil or varnish by mixing thoroughly one volume of the yolk with an equal volume of the oil or varnish, and adding gradually two volumes of water. This is a sort of basic formula.

The oil used may be raw or boiled linseed oil, or stand oil, or China wood oil (which gives a washable surface), or strong mastic varnish, or any of many mixtures of these and other things. Balsams such as Venice turpentine are sometimes used, but their effect is of doubtful quality. Beeswax dissolved in turpentine may be used in

place of the oil, or mixed with it; and this sort of emulsion is especially useful for such delicate work as flower painting.

Casein emulsions

In place of the egg yolk in this basic formula, a solution of casein may be used. Casein is often dissolved in strong ammonia; but a better solution is obtained, and that more easily, by warming one ounce of dry powdered casein in sixteen ounces of water, and adding gradually one half ounce of powdered ammonium carbonate. After the foam subsides, a thick, honey-like solution is left, and this may be used as an emulsifying agent. It produces emulsions which load more than those made with egg, and are more crisp working and "short." Casein, in the form of washed cheese, dissolved by grinding with slaked lime to a thick paste, gives an admirable medium for wall painting if you add a small amount of strong hide glue (one part in ten of one-to-ten glue solution) and thin the mixture with warm skimmed milk. With this composition it is possible to produce effects indistinguishable from those of fresco. The surface is washable (within reason) when it is dry.

Underpainting for oil

Any good tempera may be used as an underpainting for oil; and some (especially the egg temperas) lend themselves also to painting over oil, especially to rendering fine or sharp detail over or under a glaze of oil paint. The technical problems and possibilities that these techniques open up lie far beyond the scope of this introduction. Stand oil, or boiled linseed oil, or copal varnish, or combinations of these, may be emulsified with an equal part of a thick, warm solution of glue, and two parts of water added. This sort of emulsion is particularly agreeable for broad underpaintings for oil, and can readily be made to yield certain technical effects, such as are seen in the works of Tintoretto and El Greco.

Preparation of wall surfaces

All these combinations have their proper places, but they cannot be discussed in detail here. In general, they resemble the tempera

that we have been considering in working properties, but differ from it in their specific characters. They are more suitable than plain egg for working on a large scale. Admirable decoration can be carried out directly on a wall, or on a wall lined with muslin or paper, or both, with emulsions of this sort. The colors may be mixed with the emulsion to the consistency of house paint, and applied with bristle brushes, thinning with water as required. If possible, most modern walls should be lined with muslin, or better, with linen, glued on in pieces (after the wall is sized) with hot glue. Kraft paper may be hung over this with paste, or applied directly to the sized wall. An even tint may be given to the linen or paper by applying two or three coats of tempered color, or of a mixture of 16 ounces of whiting with 16 ounces of one-to-twenty-four glue solution, with or without the addition of a little coloring matter, such as ocher, red earth, black, or French ultramarine.

I can do no more here than indicate the existence of these means, and say that, in my opinion, they can best be utilized by persons who have already learned the fundamentals of tempera painting as distinguished from all other media, by the practice of the most rigorous of all tempera disciplines, that of pure egg painting. The practice that I have attempted to set forth should be regarded as an introduction to the character of tempera in general. For a given painter, with a given job to do, there is some one technique more suitable than any other. In some cases, this will be a tempera of some sort; and in a few of those, the tempera described at some length in this book. This method will, I believe, equip a painter with the experience necessary to test and understand and use effectively other methods, barely mentioned here, which he may then find better fitted to his needs.

Appendix.

TEMPERA PRACTICE IN THE YALE ART SCHOOL

Professor Lewis E. York

1) Composition sketch in three values.

This is really a drawing in the mode of color value, with an extended range of values for the sake of clarity. It is made on a middle-tone paper with black ink and tempera white.

2) Color sketch.

This is made in as many values as called for, and is a translation of the composition sketch into local colors. It corresponds with the first flat lay-in of the painting. To make this requires a decision on the final value range of the painting as well as a choice of the local colors.

PR Value range in painting

PA Value range represented by white in composition sketch

AB Value range represented by middle tone in composition sketch

BR Value range represented by black in composition sketch

3) Form drawing.

A. This is made on middle-tone paper. The drawing is picked up with charcoal and when well found is partially dusted off. It is then completed in diluted ink and tempera white. The ink and white are manipulated with a brush.

B. By pure form drawing we mean the description of forms on a flat surface by describing their planes in perspective as revealed by a light.

In form drawing in its pure state there are no lines, only flat and

graded tones. The main difference between this mode of drawing and the mode of complete visual appearance is the purposeful elimination of color.

C. In our drawings, the perspective used is really one of sentimental, not of mechanical accuracy.

D. The light and shade we employ is usually conceived as from a rather narrow source of light far enough removed from the object illuminated to figure the light rays as parallel. This light and shade system is not used with mechanical accuracy, especially in respect to cast shadows, which are included, limited, omitted, or falsified for purposes of design.

E. In our drawings we use abstract lines to manufacture tones, and also add lines of definition where desired. The lines used to establish tones, either flat or graded, are hatched or cross hatched more or less openly according to the desired variance from the middle tone. This forms an optical tone.

F. The direction of these lines may be governed by a wish for:

1. Form or volume description.

Here the form is described by the direction of each line as well as by the light and shade.

LINEAR FORM
DESCRIPTION-

2. Lack of form description.

The two sketches on the next page show: *a*, linear form description; *b*, lack of linear form description.

3. Compositional effects.

Rule: Similarity of lines gives unity; dissimilarity gives variety. Similarities possible in lines:

> a. Length
> b. Position

 c. Curvature or straightness
 d. Color
 e. Value
 f. Intensity
 g. Direction

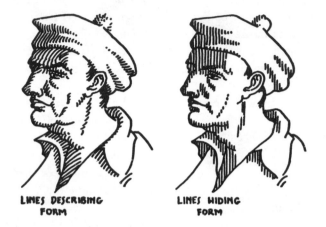

LINES DESCRIBING LINES HIDING
FORM FORM

Lines may be used to guide the eye of the spectator or to stop it.

Rule: The eye follows the length of a line, and across a gradation from the tone nearest the ground tone to that farthest removed in value.

4) PREPARATION OF PANEL.

The panels upon which we paint are made of pressed wood. The commercial name is "Masonite." They are prepared as follows.

 A. Size coat. 5% gelatine size applied to both sides.

 B. Dried for 24 hours.

 C. Five to nine coats of gesso applied hot.
 1 part 6% size
 1½ parts whiting

 D. Final coat smoothed down by means of a smooth stone or smooth flat block of wood.

 E. Final polish with very fine sandpaper.

5) Engraving design on panel.

This is done with a stylus. The engraved lines are very light, and are made only around the areas which will show a color difference in the lay-in.

6) Gilding.

Over the areas to be gilded several coats of gilder's clay are laid, mixed very thin with 5% size, or weaker size for very thin leaf. When dry, this is burnished with an agate. The gold leaf is then laid by wetting down the clay and laying the gold leaf in place. If air bubbles form under the leaf they are pressed out with a small piece of cotton. When this has dried, the leaf is burnished with an agate, and turns very dark and shiny.

7) Painting.

A. Palette normally used.

Permalba white	Yellow ocher	Cobalt blue
Ivory black	Cadmium, middle	Opaque oxide of
Vermilion	Raw umber	chromium
Rose madder	Burnt umber	
Venetian red		
Indian red		

B. Medium used.

Yolk of egg with water. They should be thoroughly mixed. The amount of water to be added to a yolk varies, being decided by the thickness of the yolk. Under no circumstances is it wise to add water to more than twice the volume of the yolk.

C. Mixing of color and medium.

Enough medium must be mixed with the color to bind it firmly to the gesso ground. The general rule for this is equal amounts of color and medium, though in some cases more medium is necessary. The safest way is to err on the side of too much medium. For purposes of easy manipulation it has been found best to make the

first mixture of color and medium rather thick, and then dilute it with water as necessary.

D. Lay-in or underpainting.

In the lay-in the entire ground is covered, each form to be rendered being laid in in its middle tone, high tone, or low tone, depending on the modeling system to be used. These tones may be the actual color wished at some point in each form, or may be an off color which will need to be painted over, completely as with a glaze, or partially, with an opaque tone, to create optically a tone wished. Sometimes when the form to be rendered requires a wide value range, we use a two-tone lay-in, the light tone being darker than the lights to be applied, and the dark tone being lighter than the dark tones to be applied.

E. Brushing.

a. Full, wet brush. This is very useful in laying in large flat tones, and in painting forms with a single brush stroke.

b. Lean, dry brush. This is used to advantage in drawing lines, in delicate hatching, and in any kind of subtle modeling or detailing.

c. Thick paint. This is useful in placing small lights, and fairly thick paint is useful in painting entire light areas.

d. Thin paint. Five or six times over an area with thin paint usually results more happily than once over with thick. Thin paint is extremely useful with a dry brush for delicate modeling. This is the secret of most of the subtlety in tempera painting.

F. Modeling.

In our pictures, the composition sketch, color sketch, and form drawing are rolled into one. The modeling is derived from the form drawing, which acts as a kind of map or chart for the placing of darks and lights. At this point a choice is made as to which sketch shall dominate. The choice is usually determined by the use to which the painting is to be put, or the position that it is to occupy, weighing visibility and taste.

G. *Modeling systems.*

1. Values.

a. Light applied first, middle tone second, and dark last. This system is similar to drawing on white paper with a dark point, or using transparent water color on white paper.

b. Dark tone first, middle tone second, and light tone last. This system is the same as used in making a pastel drawing on black paper.

c. Middle tone first, darks and lights second. This is the best system, as it does not need to be retranslated from the form drawing on middle-tone paper. It also has the advantage of working toward the extremes or accents, rather than placing them first, so that the painter can watch his painting shape up, and thus have it under better control. This is a better system than the others, too, because the spectator in viewing a picture looks at the darks and lights, and if either of these be left as the ground instead of being considered and drawn in, they may be relatively poor in shape.

2. Color and value relations.

	Light	*Middle tone*	*Dark*
A	Middle + white	Dark + white	Color
B	Middle + white	Color	Middle + black
C	Color	Light + black	Middle + black
D	Color (1)	Color (2)	Color (3)

A, B, and C, in the above table, are what we call "controlled color systems." In each of them there is but one color choice per area to be modeled. The other two tones are automatically fixed by the system. Any one of them insures a harmonious placing of the strongest color notes in each modeled form. System A is generally productive of the most colorful results. B produces a grayer effect; and C is usually very dull, unless the light areas of the painting are unusually large. In system D, all three tones of the modeling are colors chosen by the painter. This being a free choice may result in anything from a hodge-podge to the utmost unity. However, it allows for a closer manipulation of the relation between warm lights and

cool shadows, or the reverse, which is very useful to those with a naturalistic bent. In systems A, B, or C, a light color may of course replace the white, or a dark color, the black, or both, with many interesting results.

3. Opacity and transparency in modeling.

a. Opaque and opaque.
b. Opaque and transparent.
c. Opaque and transparent and opaque.

In system a, Opaque and opaque, an opaque ground is laid and another opaque color is hatched over it, openly or thinly enough to retain some of the original ground. This may be done with either similar or widely separated values, and with similar or contrasting colors. It always produces a much livelier effect than a solid tone.

In system b, Opaque and transparent, an opaque ground tone is laid and a transparent color painted over it. Painting in a transparent color is called glazing. The effect produced is similar to that of looking through colored glass. The resulting color depends on the two tones used and on the thickness of the glaze.

In system c, Opaque and transparent and opaque, an opaque ground is laid. This is then glazed with a transparent color, after which another opaque tone is applied. The two top tones must be used sparingly enough to allow the opaque lay-in to do its work. This is a very valuable method for painting semi-transparent darks.

4. Scale of brushing.

With a fast-drying medium such as egg tempera, the brush strokes usually show. We try to make each stroke have a purpose, as explained under "Form drawing," and also to keep it in scale. The scale is usually dictated by the size of the panel and the distance from which it is to be seen. For best visibility, three times the greatest length of the panel is the spot for the spectator, unless the pattern-scale of the painting invites him closer, or for some reason he is prevented from coming so close.

INDEX